IMAGES
of America

OKOBOJI
AND THE
IOWA GREAT LAKES

ON THE COVER: There is no better way to beat summer's heat than a dip in Okoboji with family and friends. Note the broad-brimmed hats and ladies' swimming attire. Unlike today, "bathing" saw women modestly covered from head to toe, while men's outfits are slightly more revealing and often made of wool. This group has likely rented a rowboat for nonswimmers from an Arnolds Park concessionaire. (Courtesy of Iowa Great Lakes Maritime Museum.)

IMAGES
of America

OKOBOJI
AND THE
IOWA GREAT LAKES

Jonathan M. Reed

ARCADIA
PUBLISHING

Copyright © 2017 by Jonathan M. Reed
ISBN 978-1-4671-2493-5

Published by Arcadia Publishing
Charleston, South Carolina

Printed in the United States of America

Library of Congress Control Number: 2016949799

For all general information, please contact Arcadia Publishing:
Telephone 843-853-2070
Fax 843-853-0044
E-mail sales@arcadiapublishing.com
For customer service and orders:
Toll-Free 1-888-313-2665

Visit us on the Internet at www.arcadiapublishing.com

CONTENTS

ACKNOWLEDGMENTS

Thanks are in order to Mary Kennedy, curator of the Iowa Great Lakes Maritime Museum in Arnolds Park. In many ways, she is this book's uncredited author who brought perspective and insight to the hundreds of photographs gathered for this effort—a life well-lived in Okoboji will do that. All things positive and correct in this book are Kennedy's; the mistakes are my own. A debt of gratitude is also owed to Mary's husband, the late Stephen R. Kennedy, who brought us the *Queen II* and the maritime museum, and helped save Arnolds Park amusement park in 1999. Without these efforts, much historical fact may have slipped past us.

Another person whom history did not get past is local historian and author R. Aubrey LaFoy. Meeting 90-year-old LaFoy this year proves that if we pay attention, history is all around us every day. Thanks also go out to my good friend and coworker James Egolf for his support, and to Cindy Schubert at the Dickinson County Historical Museum in Spirit Lake, who helped answer many questions.

This book is the realization of a nagging suspicion that Okoboji and the Iowa Great Lakes are changing. While the waters are probably as pure as when my great-grandparents bought property here in 1902, the culture has certainly changed. Hundreds of small lakefront rental cottages are gone, replaced by million-dollar homes and condominiums, and this has also altered the Iowa Great Lakes' economy in fundamental ways. But as this book hopefully illustrates, change at Okoboji is the only thing that is constant.

Unless otherwise noted, all images appear courtesy of the Iowa Great Lakes Maritime Museum located in Arnolds Park, Iowa.

INTRODUCTION

Some call it "One of the World's Three Blue-Water Lakes;" to others it is just "Okoboji," a place of recreation and surprising beauty. The Iowa Great Lakes, nestled hard up against Minnesota's southern border, are unique among other Midwestern chain lakes. Where a 20-foot sounding is considered "deep" for most, this area's glacial centerpiece, West Okoboji, descends to 136 feet, complementing the chain's shallower, warmer lakes. Early visitors saw the sturdy burr oak trees ringing the chain offered fuel and building materials while at the same time providing habitat for both grassland and woodland species. Trapping, hunting, and fishing were excellent. The earliest nonnative visitors who braved life on the frontier—explorers, hunters, trappers, and fishermen—came and went.

Explorer and cartographer J.N. Nicollet first mapped Spirit Lake in 1838, when western Iowa was still considered frontier and life was difficult, if not dangerous. Following 1857's Spirit Lake Massacre, the rescue expedition came from Fort Dodge, which was largely still a fort in the sense of providing safety and refuge. But with an optimistic eye toward future peace, early settlers came and stayed, enamored with the local beauty. A courthouse was erected in 1860, and the first houses and businesses not long after. Within a dozen years of the massacre, Big Spirit Lake was known and well regarded for its natural offerings. The earliest settlers included farmer Alvarado Kingman, who established a substantial acreage on Spirit Lake's west shore, and entrepreneur Orlando Crandall, who helped erect and eventually purchased the earliest hotel, Hunter's Lodge, on Spirit Lake's north shore. Before long, Crandall's Lodge was joined by numerous other early hotels, including the Lillywhite Lodge and the magnificent 1883 Orleans Hotel on the south shore—a grand and massive investment by the Burlington, Cedar Rapids & Northern Railway. For many decades, Big Spirit Lake was the lake to visit, not West Okoboji.

The deep blue lake was far from ignored, though. Arnolds Park was already well known from the massacre. Retired circuit preacher Samuel Pillsbury moved into the Gardner's abandoned cabin, and Pillsbury Grove (now Pillsbury Point) was the site of well-publicized gatherings through the 1870s. For the next decade, railroad fever gripped the area and once the Milwaukee Railroad's service pushed through to Arnolds Park and Okoboji, development occurred at a rapid pace. Only a scant few months after the railroad reached Arnolds Park in 1882, W.B. Arnold began taking boarders into his home. Sensing opportunity, a dining and dance hall followed, along with numerous amusements, such as the 1889 Chute-the-Chute water toboggan attraction. The area's first vacation cottage was called Seven Gables by its owner, George Dimmitt of Des Moines, but Okoboji gained prominence when state supreme court judge Josiah Given erected his own summer cottage nearby.

Camping was enjoyed by masses, with Pillsbury Point, Dixon's Beach, and Hawkeye Camp at Spirit Lake's Minnewaukon Beach drawing thousands over the course of a summer. There was abundant fishing, boating, bathing, and entertainment from Spirit Lake's Chautauqua and the amusement parks at Arnolds Park. Fueled perhaps by the success of the annual Bible & Missionary Conference at Arnolds Park, recreational retreat campgrounds were established at various locations around the lakes by Lutheran, Presbyterian, and Methodist orders. One particularly impressive and early investment was by a fraternal order, the Grand Commandery of Knights Templar of Iowa. Templar Park annually drew members of the Masonic order and, in later years, was open to public use until razed in 1979. Today, camping can be enjoyed in state parks and RV campgrounds.

For many years, only a few poor roads existed around the Iowa Great Lakes, making water navigation a logical endeavor. Locally made sailboats and rowboats from John Hafer, the Henderson brothers, and the Arp brothers plied the waters until steamers arrived in the 1880s. While the *Alpha*, *Favorite*, *River Queen*, *AJ Hopkins*, and *Lelia* are all but forgotten, others live on in legend: the *Okoboji*, *Des Moines*, *Sioux City*, and *Iowa* were relied upon for transport around the lakes. The *Queen* was one of the early steamers that thrilled passengers in all the lakes. She was first launched in Big Spirit Lake and moved in 1900 to travel the Okobojis until swing bridges were removed. She was then finally on West Okoboji only. She left the lakes in 1973.

With easy water access, vacation development continued, with dozens of mom-and-pop resorts springing up around all the lakes, joining larger establishments like Templar Park, Manhattan Beach, and the Inn. The glacial, rocky soil meant farming and grazing were difficult along the shore, but developers liked what they saw. Neighborhoods like Maywood, Brownell Heights, the Van Steenburg Estates, and Triboji all bear the names of promoters and developers of the Iowa Great Lakes. When developing the Francis Sites along East Lake Okoboji in 1919, L.E. Francis wrote that he invested in the lakeshore "because I believed in the future of our lakes. I knew from my travels that lakes are scarce and that very soon lake shore lots would be highly valuable." Indeed.

The Roaring Twenties were perhaps one of the most lucrative periods here. The pre-Depression economy was booming, progress on roads and bridges improved access to the Iowa Great Lakes, and the Midwest's farm population was seeing something heretofore unknown: leisure time. The amusement parks at Arnolds Park—Benit's on one side, and Peck's on the other—saw unprecedented investment in rides, roller coasters, dance halls, skating rinks, moving picture shows, and other carnival-type activities. Dancing was a favored pastime of this era. Imagine boarding your launch and motoring to dances at Manhattan, then to the Casino Ballroom at Terrace Park, on to dancing at the Roof Garden and Central Ballrooms, and finally ending up at the Inn for a last dance and breakfast at midnight.

Even small, local businesses grew to take on mythic status where annual patronage was obligatory by vacationers: the Pantatorium laundry, the Black Walnut candy shop, Harry's Kurio Kastle, Muriel Turnley's Peacock Inn, Ralph "Hamburger Red" Clinton's diners, Oak Hill, and later, the Wharf, Tony's Drive-In, and Vern & Coila's.

Through the years, the lakes themselves have changed little. Improved bridges over natural connections, the spillway created between Spirit Lake and East Okoboji, and an outflow dam installed at the foot of Lower Gar lake are perhaps the most notable—and these were constructed to deal with inevitable high- and low-water conditions. Rather, the biggest changes have been reflected in our society: docks were rare enough that they could be listed in a few lines. Modest three-room resort cottages have given over to substantial year-round homes, each with its own dock. And it is a rare family where the wife "summers" at the lake with the children while the husband works in town.

If there is one message to convey about Okoboji history, it is that everything changes over time. Businesses come and go, buildings and cottages change, movers and shakers move on, projects are abandoned or completed, and a new generation of residents and vacationers builds its own indelible memories. Hopefully, these pages will help you hear some of these echoes of the past.

One

THE EARLY YEARS

No one today can understand what Native American tribes and a few brave frontiersmen saw when approaching Okoboji and the Iowa Great Lakes—after traveling miles of unbroken prairie, the oak-edged lakes must have been a refreshing sight. Closed to all but the bravest pioneers, settlement in the Midwest was a slow and lonely endeavor. Apart from early (and ill-fated) pioneer settlers like Rowland Gardner, this part of Iowa was still being explored. Even as late as the 1860s, many maps and school textbooks referred to western Iowa as being set aside as Indian hunting grounds. But progress surely did come, with the first structures built in Spirit Lake in 1857 following the massacre—essentially a stockade—and more buildings erected as word of the area's beauty and resources spread.

No one knows why 13-year-old Abbie Gardner was spared and taken captive during the 1857 Spirit Lake Massacre. Her strawberry blonde hair may have made her stand out, making her valuable for trading. This undated photograph may be from her wedding to 19-year-old Casville Sharp later that same year.

Abbie Gardner Sharp returned to Arnolds Park in 1883 and successfully lobbied the state to build the nearby monument and relocate the graves of 17 persons killed to its base. This desolate pile of rocks is likely the original grave marker.

Alvarado Kingman, shown with his family, established a successful farm on Spirit Lake's west side in 1858. Violent skirmishes were occurring both to the south and to the north, and he joined the Sioux City cavalry in 1861, assigned to "frontier duty at a time of serious trouble and peril from Indian raids." His wife, Esther, died in 1890, and he moved in with his daughter in Spirit Lake.

The words "pioneer preacher" fail to convey the fearlessness required to bring one's family to the frontier, but Rev. Samuel Pillsbury must have had it. A Methodist circuit rider, Reverend Pillsbury traveled throughout Wisconsin and Illinois before coming to Iowa in 1863 and taking up residence in what was the Gardner cabin. His talks at Pillsbury Grove drew dozens—if not hundreds—and were publicized in area newspapers.

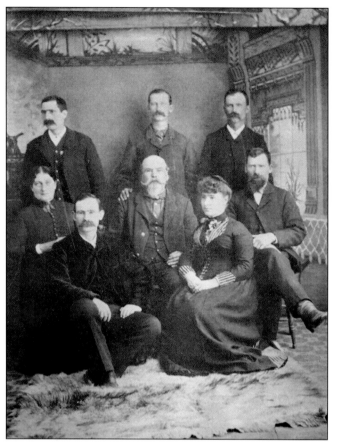

Zina Henderson and his family settled near Lake Minnewashta in 1864, with a homestead granted by Pres. Ulysses S. Grant in 1873. The Hendersons contributed greatly to the area, having built the Henderson Bridge between Minnewashta and Lower Gar. Shown are, from left to right, (first row) Bain and Mae; (second row, seated) Mary, Zina, and Harvey; (third row, standing) Elmer Oscar, Alphonso Alonzo (also known as "Fon" or "Phon"), and Frank Henderson. Their original log cabin stood until 1943. The land is now Henderson Woods natural area, next to Minnewashta and Lower Gar lakes.

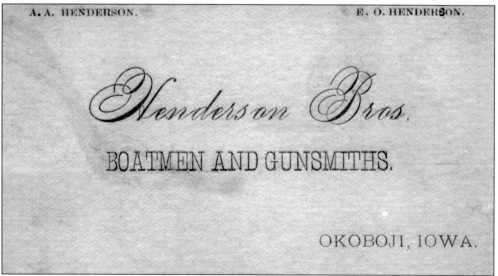

The Henderson brothers were boatbuilders and gunsmiths—both valuable occupations at the time. At the family farm, beginning about 1882, they built and operated several steamboats, including the *Alpha, Hiawatha, and Milwaukee,* and purchased the *Queen* in 1900. Eventually, they erected a shop and a house where Mau Marine is now located.

The c. 1875 photograph above shows very early Spirit Lake with dirt roads and few substantial buildings. Northeast toward East Okoboji, the white structure in the distance is the Minne Waukon House hotel, which was only a few years old. Note the lumber stored outside, possibly for future homes to be constructed—a building boom was anticipated.

At this time, there were few roads, and one had to secure a ride on a stage line to travel to Jackson, Minnesota, which had just received rail service. With stops at hunting lodges along the way, it was about a three-hour ride from Spirit Lake.

STAGE LINE
FROM
JACKSON TO SPIRIT LAKE.

Coaches leave Jackson every morning at 8 o'clock. Leave **Spirit Lake** at 1 o'clock, touching each way at

Hanters' Lodge, Lillywhite Lodge

And other points of interest on Spirit Lake.

Especially solicits

PASSENGER AND EXPRESS

Patronage. 91

J. A. TWILLEGAR, Prop'r.

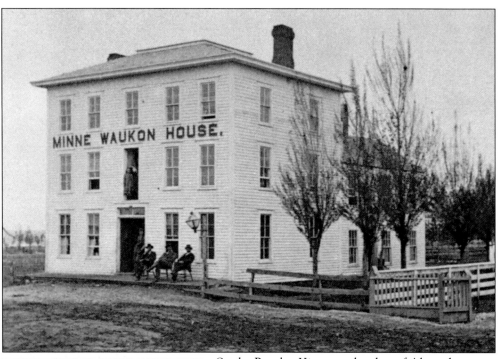

Settler Rosalvo Kingman, brother of Alvarado Kingman, established the town's first hotel, the Lake View House in 1859. But Spirit Lake was growing, and George Edwards erected the Minne Waukon House in 1874. Edwards left the area soon after completion but it was run successfully for decades by different operators. The newspaper ad from 1876 shows lessee E.P. Ring as the proprietor. Newspaper accounts suggest he later returned to farming.

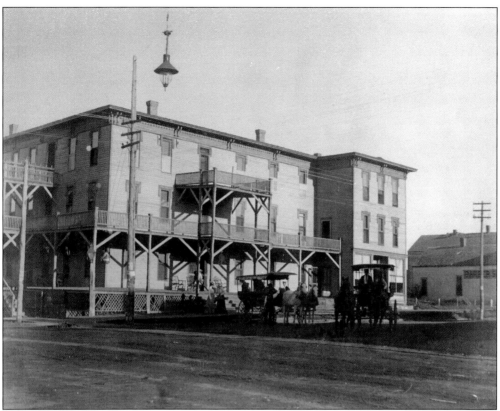

Orlando Crandall had built a regular patronage at his hunting and fishing lodge on Big Spirit. However, he bought the Lake Park House in town that catered to a different trade, naming it the Crandall House. Unlike his fishing lodge, this hotel at Hill Avenue and Lake Street had modern conveniences like plumbing and, eventually, electric lights. The hotel was razed in 1902 and replaced with the Antlers Hotel.

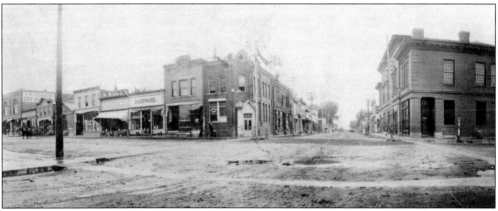

By the beginning of the 20th century, Spirit Lake had a large courthouse and business investment was evident despite the muddy, rutted streets. The downtown had banks, a hardware store, a pharmacy, and even an opera house block at right. At the extreme left, note the A.M. Johnson Dry Goods Store, which set the architectural tone at the time. That building is recognizable today at Hill Avenue and Highway 9/71.

ALONG WEST SHORE, SPIRIT LAKE, IOWA.

The major thoroughfare between Spirit Lake and Jackson, Minnesota, ran along the west side of Big Spirit Lake. At times, the roadway was impassable, such as during high water. This ornate rustic bridge was known as the Buffalo Run Bridge; it was not only an engineering feat but was also a major landmark. The bridge was replaced when modern roads were built.

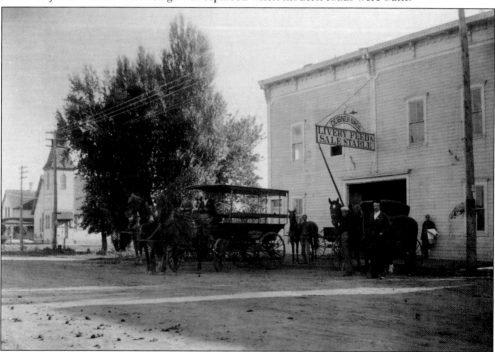

Horses were the only means of personal transport for most until well after World War I. For local residents and visitors alike, equine-powered drayage and livery were commonplace. Deibner Bros. Livery had a prominent location in Spirit Lake at what is now the corner of Hill Avenue and Sixteenth Street. This 1895-era photograph shows mud streets covered with manure droppings.

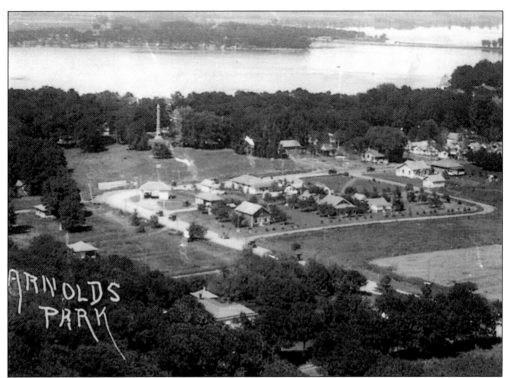

Arnolds Park remained largely a phenomenon of the railroad depot and the amusement park. For many years, only small businesses and homes were erected in this vicinity. As late as the early 1920s, as this aerial photograph shows, only a few cabins and fishing retreats had been built. The 1895 monument to the Spirit Lake Massacre is clearly visible, with little construction around it.

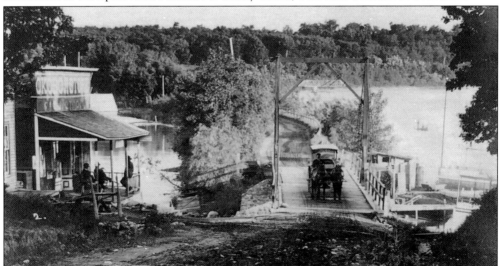

Conditions like this mud road were commonplace, and stretches of paved road today were once rugged and treacherous. This 1900-era image of the Okoboji Store at the grade at Okoboji is typical. Old-timers at the time would have marveled at how wide and high above the water the path was—it had been improved significantly and even sported a swing bridge for steamers to pass through.

With early settlers holding a mind-set devoted to progress, initial development on the shorelines of both Spirit Lake and West Okoboji happened quickly. By the end of the 19th century, only some of the smaller neighboring lakes would have shared this undeveloped view. Center Lake is higher than Okoboji, shallower than all the others, and sits at the bottom of a bowl of small hills. This photograph from about 1897 shows something rarely seen today—the island at Center Lake, a function of years of low rainfall. Although difficult to get to, it was often a favorite hide of duck hunters. Today, only smaller area lakes like Hottes Lake and Little Spirit Lake have wild and rugged shorelines like this.

Two

RAILROAD AND
STEAMSHIP ERA

In the early days, it was a full-day's carriage ride to get here from Ruthven, only 21 miles away. Traveling from Fort Dodge, Des Moines, or Cedar Rapids required many days' planning—a virtual expedition. Then, two railroads pushed through in 1882 and developers liked what they saw. Within a year, plans were made to erect the grandest hotel in the upper Midwest, the Orleans. With local roads few and far between—the lakes abutted farmland or prairie—sailboats were the fast means of travel until the first steamship was brought in, which was quickly joined by others. With rail service and a few primitive roads, by the early 1890s, day trips were possible. Vacationers could now leave faraway places like Omaha, step onto the railroad platform in Arnolds Park, Okoboji, or Orleans by lunchtime, and have enough time to spend a stifling summer day bathing. Going to another resort or an acquaintances' cabin only required paying a steamship fare. Need to be picked up? Simply wave a white towel from a dock. Thus it was until modern roads slowly began circling the lakes in the 1920s through the 1950s.

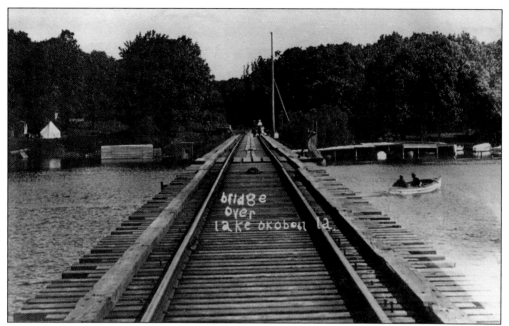

Community promoters knew nothing improves the economic condition of a town like the arrival of the railroad. For more than a decade, newspapers printed stories weekly on the building "railroad fever" gripping this part of Iowa. Then, at nearly the same time in 1882, the Burlington, Cedar Rapids & Northern Railway (BCR&N) and the Chicago, Milwaukee & St. Paul (the Milwaukee Road) established paths to the lakes area.

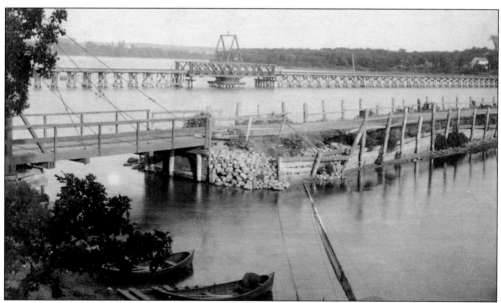

The engineering to cross East Okoboji must have vexed railroad engineers. The grade, foreground, took decades to be lifted and enlarged for wagon traffic. This photograph—probably from before 1900—shows one of the earliest railroad swing bridges with guardrails and a superstructure. Note the number of pilings required to support an entire train across the open-water span, which at this time had no earthen fill at either end.

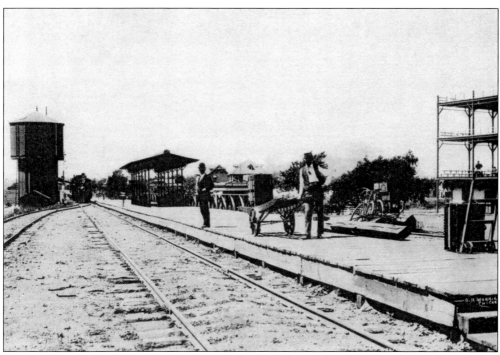

In 1882, when the Burlington, Cedar Rapids & Northern Railway succeeded in building its line to Orleans at the south end of Spirit Lake, the company also elected to build the grandest hotel west of the Mississippi the following year. This photograph shows not only the depot, water tower, and platform, but also glimpses of the massive Orleans Hotel verandas on the right side.

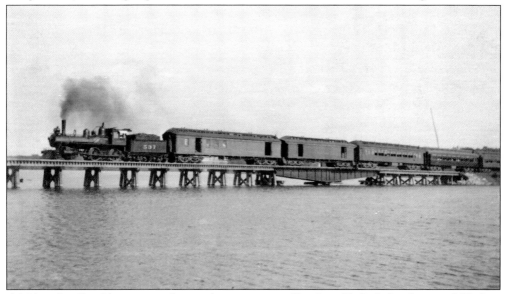

A Milwaukee Road locomotive, having let passengers off at Arnolds Park, heads toward Okoboji with baggage car doors open. In comparing this with the earlier view on the previous page, one can see the right side of the crossing has been filled in, requiring fewer trestle stanchions. This iron swing trestle is the one currently in use on the bike trail, now raised and fixed for pleasure boat traffic to pass through.

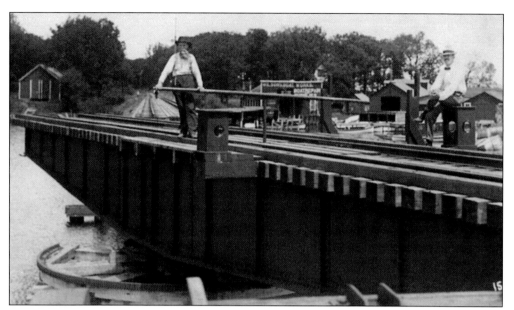

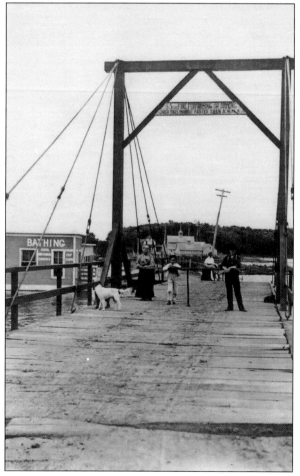

These steamboat-friendly swing bridges were turned by hand. The view in this photograph, possibly from the 1910s or early 1920s, is looking toward the Wilson Boat works—now Mau Marine. It shows the operator using a long pole for leverage to manually turn a set of gears underneath to rotate the trestle.

A well-known fixture in Spirit Lake, Martha Shear (called "Grandma Shears" by locals) operated the swing bridge at Spirit Lake for many years. Here, two assistants perform the labor. Born in 1836, Shear lived in Orleans until her death at age 93. Note the sign admonishing travelers of a $5 fine "for riding or driving over this bridge at faster than a walk."

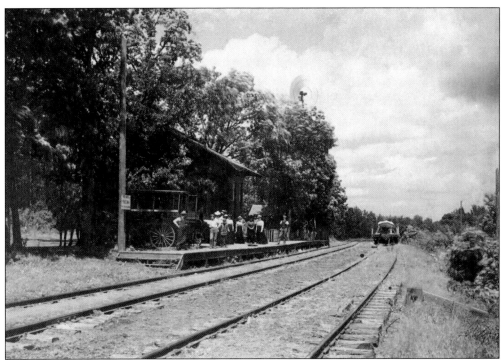

Nestled in an oak grove at the end of present Depot Street, and with the expanse of East Okoboji to the right, the Okoboji depot was one of the busiest on the Milwaukee line. Once trunks and suitcases were unloaded for liverymen to deliver to cottages or hotels, a vacation at Okoboji could begin. Note that a sailboat is being delivered by railcar in this photograph.

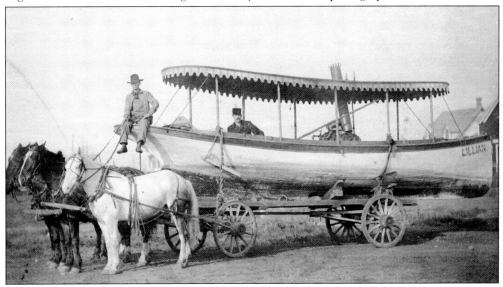

Roads were so poor in the early days that the only efficient way to get around the lakes was by steamboat. The steamer *Lillian* is shown here being transported by horse and wagon to Okoboji about 1893. *Lillian* was the property by Al Hagedon of Ruthven, who owned a home at Manhattan Beach but invested heavily to make Lost Island Lake a functional resort. The fate of *Lillian* is unknown.

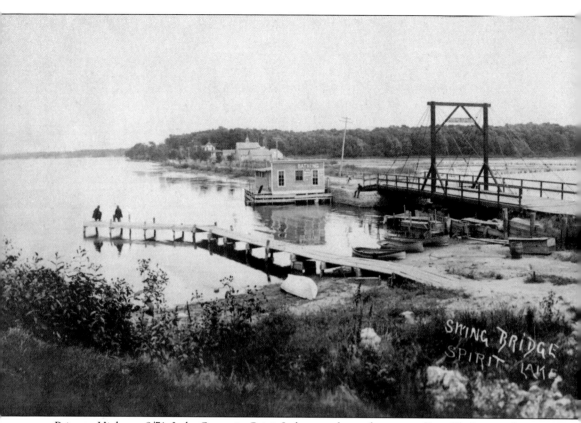

Prior to Highway 9/71, Lake Street in Spirit Lake was the path to cross East Okoboji, making it a major thoroughfare. A public landing here was approved in 1887, with boatbuilder Peter Arp given a concession to operate a rental business. G.P. Hopkins had his boat livery across the street. Gardner P. Hopkins operated the steamer *A.J. Hopkins* (named after his wife, Arminta) and the

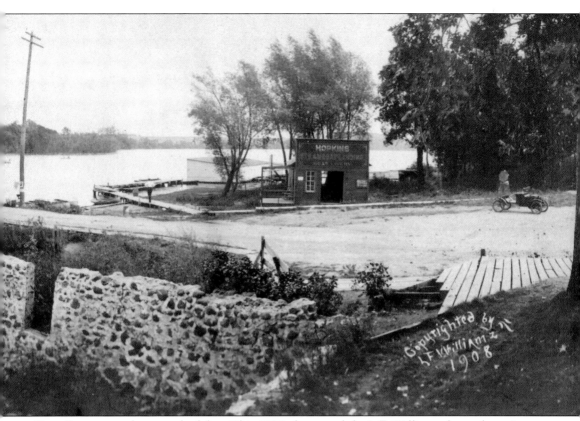

River Queen steamboat on the lakes. This 1908 photograph by L.F. Williamz shows the swing bridge, the public access dock, and bathhouse, where one could buy general merchandise, soda pop, and cigars. On the right side, the Hopkins Boat Livery stands at the water's edge. The motor vehicle at right is likely Williamz's, and may be a c. 1905 Waltham-Orient buckboard.

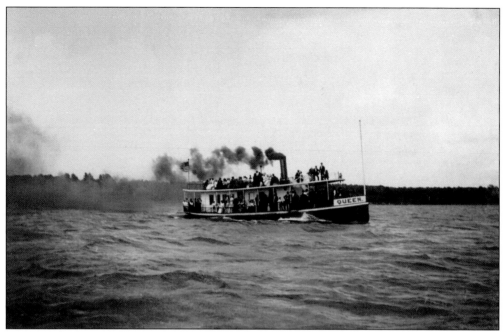

No steamship had a longer reign in the Iowa Great Lakes than the *Queen*. Shown here on Big Spirit Lake, she was commissioned by the BCR&N Railroad in connection with its new Orleans Hotel and launched on July 1, 1883. The boat was originally fitted with an open upper deck, and passengers contended with sun, soot, and cinders from the steam engine. A roof covering the top deck was added in 1910.

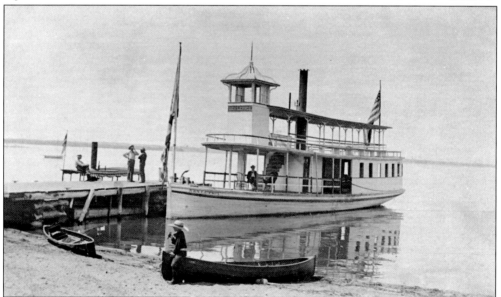

The BCR&N had a steamship, and the Milwaukee Railroad needed one to compete. Unlike the *Queen*, the *Ben Lennox* had a short life span, from launch in 1884 to just 1899. Initially named after a Milwaukee Road executive, the craft was renamed *Manhattan* in 1897 by the Manhattan Beach Company. She was sold to Fred Roff, who incorporated many parts into building the *Okoboji* in 1900.

With the hotel Orleans struggling and Big Spirit Lake water dropping, the *Queen's* usefulness diminished. An offer to buy her came through, and in the winter of 1900, the steamship was moved over the isthmus to East Okoboji. She fell through the ice near the Spirit Lake swing bridge and remained stuck there until purchased by Elmer and Fon Henderson. This photograph shows the *Queen* up for winter some years prior to the move.

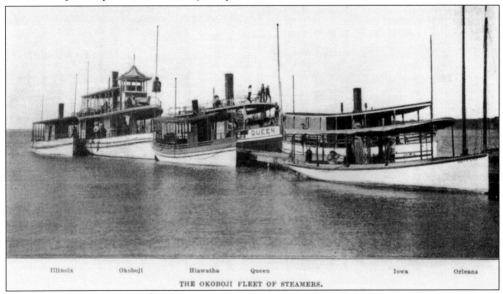

| Illinois | Okoboji | Hiawatha | Queen | | Iowa | Orleans |

THE OKOBOJI FLEET OF STEAMERS.

By 1911, the fleet of steamboats was largely under the ownership of the Okoboji Steamship Company, catering to passenger loads of all size as they traveled both East and West Okoboji Lakes. The largest at left, *Okoboji*, was claimed to hold 300 passengers, with the somewhat smaller *Queen* rated at 250.

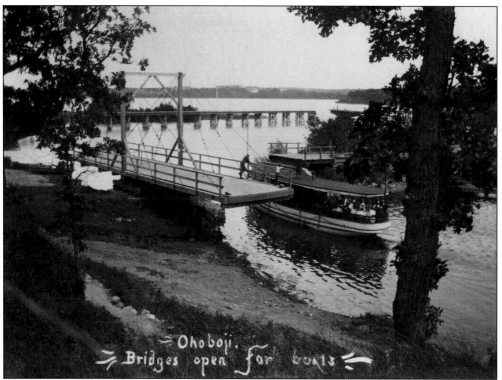

The *Iowa* makes her way from Smith's Bay into East Okoboji. Steamship operators and railroads had to be aware of each others' schedules to turn swing bridges without creating traffic problems. In this photograph, both bridges are open, with the Okoboji bridge operator and a young friend watching the *Iowa* quietly steam by.

With the Spirit Lake swing bridge open, the 58-foot, steel-hull *Des Moines* makes its way into upper East Okoboji Lake, past a bathhouse. Bathers in the water wear hats, and a swimmer is about to leap off a diving board at the left side of the bathhouse. D.S. Blakey owned that parcel of land and put up the bathhouse in 1907.

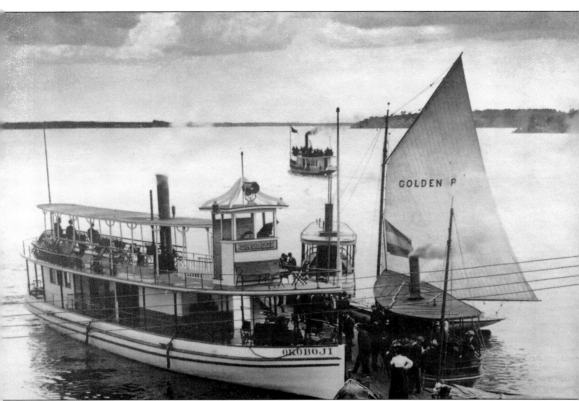

With the nearby railroad depot, the amusement park, hotels, restaurants, and various attractions to draw crowds, the Arnolds Park pier was always a busy place in the summertime. Pictured here is *Okoboji* at dock with Captain Roff leaning over to speak to someone below, while the *Queen* steams away with a full passenger load on the upper deck. The *Golden Rule*, a passenger sailboat, is at dock with (possibly) the *Des Moines* and *Sioux City* and a private launch awaiting passengers. The *Golden Rule* was owned by H.C. Mills and launched in 1899. "She is a dandy," the newspaper remarked, "and one of the largest boats on the lakes." Note the natural shoreline in the distance and the lack of docks and cottages. At the time of this photograph, about 1905, only the affluent could afford to build summer homes on West Okoboji—a fact that remains true today.

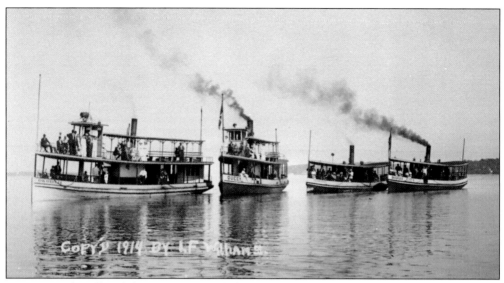

In 1914, Fred Roff and the captains of Okoboji Steamship Company proudly pose for a fleet photograph, from largest capacity to the smallest. The *Okoboji* carried 300 passengers, the *Queen* 250, the *Sioux City* 125 passengers, and the *Des Moines* 90. Launched in 1911, the steel-hulled *Sioux City* was retired in 1942 and cut up for scrap as part of the war effort.

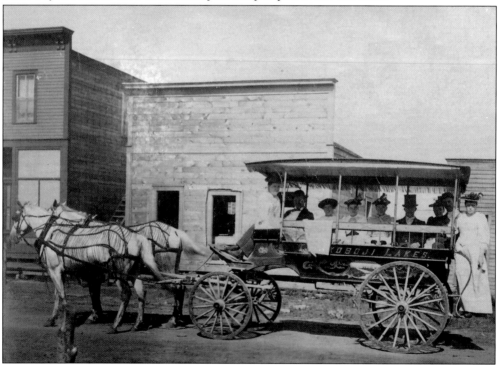

Well into the 1920s, it was common for visitors to step off a train and onto a carriage to reach their cottage or hotel destination. This photograph, possibly from about 1900, shows four stylishly dressed couples taking such a ride, with John Deibner operating his hack. There were numerous livery operators throughout the area accommodating this passenger trade. One promised "good rigs and careful drivers furnished."

Families, local residents, vacationers, and travelers all passed through Arnolds Park. With West Okoboji within sight of the railroad depot, people like these would head for the piers and board steamers to cottages and hotels all over the Iowa Great Lakes. A sand beach, the Park Theater, and other amusement park attractions would no doubt lure them back for entertainment. An automobile in the shadows places this picture about 1915.

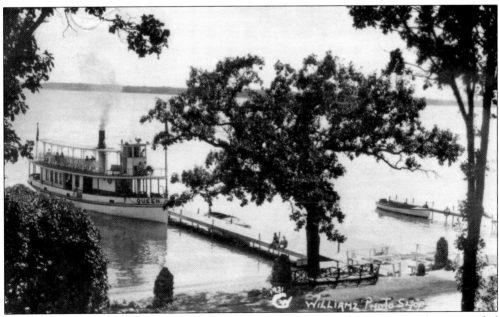

Once road and highway improvements began in the 1920s, steamboats were no longer needed for travel around the lakes. Those remaining, like the *Queen*, became excursion vessels offering sightseeing trips for tourists. The *Queen* continued doing so until leaving the lakes in 1973. Here, she is shown stopping for passengers at the Inn resort in 1931.

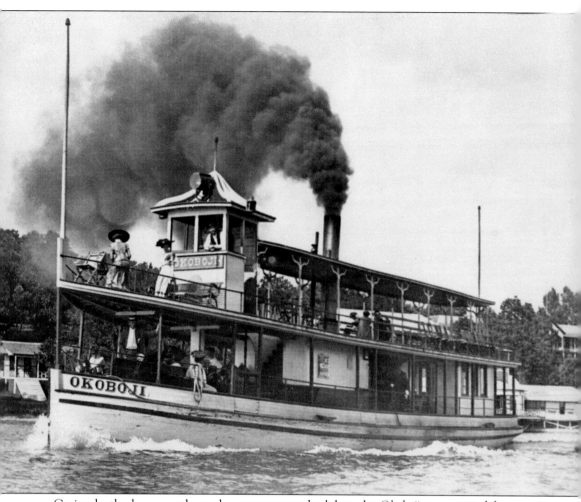

Curiously, the largest and grandest steamer on the lakes, the *Okoboji*, was created from parts salvaged from another, financially troubled steamer, the *Manhattan*. When the resort that owned the *Manhattan* went bankrupt in 1898, Fred Roff bought its old steamer. In 1900, he built and launched the *Okoboji* with many of its fittings, delivering passengers on both East and West Okoboji. Mustachioed Captain Roff is seen here at the helm during the craft's early years. News accounts report the large 50,000-candlepower spotlight at the wheelhouse was installed in1902 and "will penetrate three quarters of a mile." While stylish, the ornate *Okoboji*'s fatal flaw was its wooden hull—steamships on the lakes had a lifespan of only 20 years. The *Okoboji* was scrapped in 1922.

Three

RESORTS, HOTELS, AND CAMPS

Today's tourist economy is very different from that of earlier generations. Instead of wall-to-wall million-dollar private lakefront homes, numerous resorts and campgrounds were found around each of the lakes. In early days, camping was primitive, and resorts were modest mom-and-pop affairs, ranging in size from just a few cottages up to a couple of dozen cabins. A visiting family could rent a cottage or cabin and be assured of a place to sleep at night and not much more: screens instead of air-conditioning, running water but not necessarily heated water. Cooking was accomplished outside on a fire of one's own creation, but a few cabins offering modern conveniences would contain a stove. Some resorts included meals as part of a package (usually in the owner's home) or at a stand-alone shop. Guests had to entertain themselves with fishing, renting rowboats or sailboats, or bathing (meaning swimming). Some names are familiar today, such as the Inn, Manhattan Beach, Crescent Beach, Peck's, and Trigg's; but far more are gone, like the Villa, Babcock's Cottages, Brooks Beach, Crandall's Lodge, Valtross Lodge, Gregerson's Cabins, Log Cabin Resort, Vestergaard's Resort, Pugh's Cabins, and Gerk's Resort.

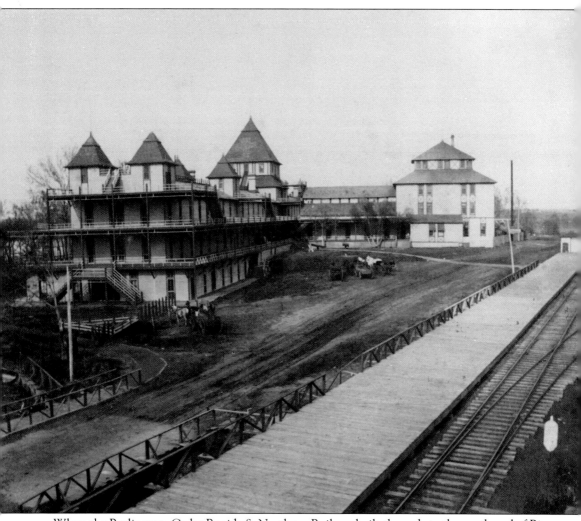

When the Burlington, Cedar Rapids & Northern Railway built through to the south end of Big Spirit Lake in 1882, executives saw opportunity to create a resort that would put the location—and the railroad—on the map. The Orleans was only steps away from the station, and it surely must have been breathtaking after hours of rail travel. A 3,000-foot-long promenade of grand verandas, 16 feet wide, caught breezes from the lake. Amenities were the most modern of 1883 for wealthy clientele. Each of the 200 guest rooms even had its own bath. The magnificent Orleans's days were numbered, though. Over the next decade, lake levels dropped by eight feet, and the financial Panic of 1893 decimated the Midwest's wealthy. Growing liquor prohibition concerns and a windstorm that severely damaged the ornate property spelled the end, and the railroad began demolition in 1898. The hotel in this form was a memory by 1900. A precursor to the spillway from Spirit Lake is visible in the lower left.

Historian R.A. Smith points out that in the early 1870s, "it took lots of endurance, energy and time to make the trip" to Spirit Lake. Englishman William Lillywhite realized that effort and, in 1872, built his hunting and fishing lodge on the southwest shore of Spirit Lake. Very popular, the lodge was sold a few years later and investors added more buildings, calling it the Westside Hotel.

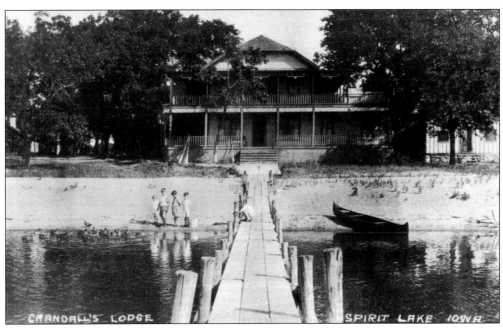

Crandall's Lodge was built on the site of the first hotel in the area, the 1871 Hunter's Lodge. Entrepreneur Orlando Crandall bought the property—it is assumed he helped build Hunter's Lodge—and began adding more rooms and amenities in 1879. The broad, clean Crandall's beach was a favorite of vacationers for decades. One of the longest-lasting resorts, Crandall's Lodge was torn down in 1975.

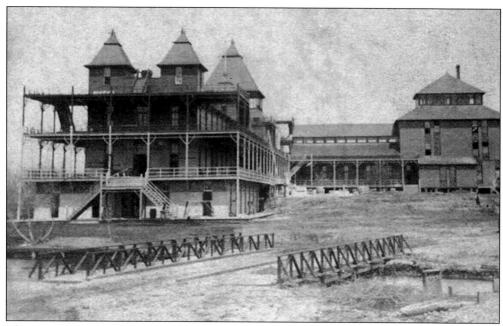

The original Hotel Orleans featured wide verandas, towers, bathrooms in every suite, and dining room menus catering to those with refined tastes. Turbulent economic times and social change, particularly liquor prohibition, soon made the resort financially unstable. Demolition began in 1898—with some fixtures used in other area hotels—but investors refused to give up on the idea of a hotel in this location.

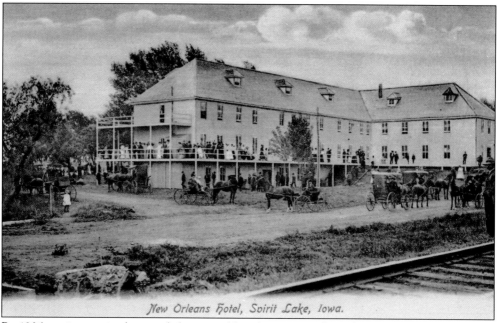

New Orleans Hotel, Spirit Lake, Iowa.

By 1906, an impressive but much less grand hotel was erected on the site by John Burmeister. The New Orleans Hotel offered electric lights in 1907, a public dining room, and a ballroom for weekly dances. It burned in 1908 but was rebuilt by Guy Burnside; however, that hotel burned in 1909. In all, there have been four hotels on the site, now occupied by a private residence.

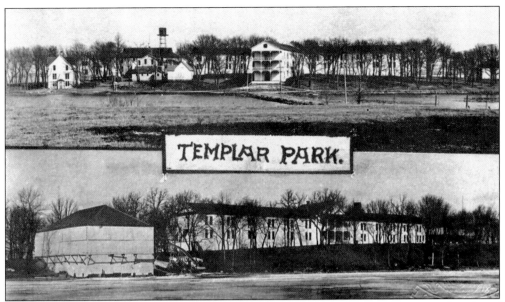

In 1885, the Grand Commandery of Knights Templar of Iowa purchased 21 acres on the edge of the Kingman property on Spirit Lake, and the organization held its first annual conclave there in 1890. Officers and members conducted parades on the grounds, and apartment rooms were eventually constructed. These original buildings were destroyed by fire in 1917.

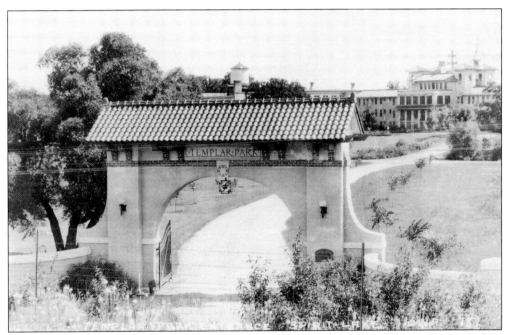

Templar Park's grounds changed substantially over the years, with parade grounds added, then dug out for a lagoon, and even a small golf course put in. The property was closed in 1972 and disposed of by the Knights Templar in 1977. The Templar Park Recreation Area was developed by the state in 1987, but this grand entry archway still greets visitors today. The fireproof buildings from 1919 are visible in the background.

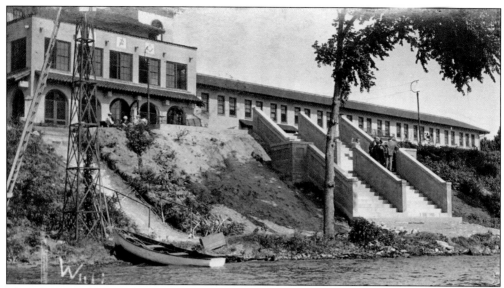

This photograph, probably from 1919, shows not only the new fireproof apartment rooms at Templar Park, but also the lakeside pavilion and the dramatic double staircase down to Spirit Lake. The pavilion was a popular site for dances, meetings, and receptions but was razed in the early 1990s. Now part of the state park, only the staircase remains.

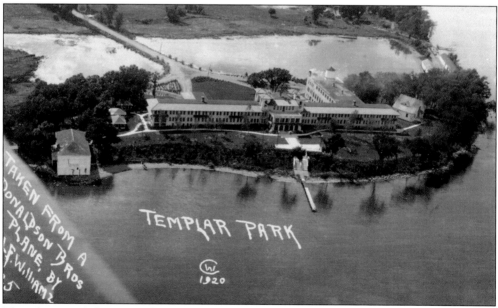

This photograph by L.F. Williamz, who pioneered aerial photography in this area, shows the extent of Templar Park's grounds. Summer cottages near the pavilion (at left) had been erected for individual Knights Templar. All this land was subdivided when the resort closed, and the great hall was demolished. It is now the Templar Park Recreation Area, maintained by the State of Iowa.

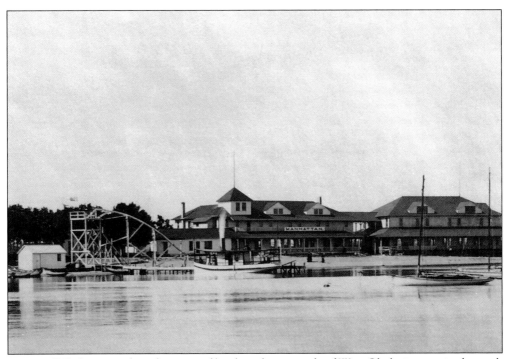

Investor D.B. Lyon purchased a point of land on the west side of West Okoboji, organized a stock company to sell lots, and erected the grand resort complex Manhattan. However, the initial venture shown here was too remote to succeed. It went bankrupt in 1899, but other entrepreneurs struggled through until 1933 when it was made into a cottage colony and the hotel demolished.

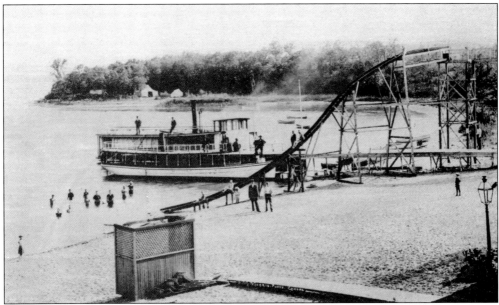

The Manhattan resort was serviced not only by its own steamship, the *Manhattan*, but by other steamships as well. The resort offered first-class dining and entertainment, as well as more exciting activities, like this waterslide. Each hotel room offered a lake view, and the amenities were first-rate: a bathhouse, a dancing pavilion, a restaurant, and even a bowling alley.

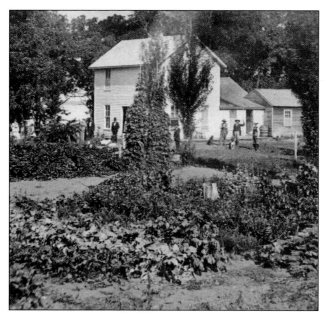

News accounts tell little about Wesley Arnold's business acumen, but as rail service approached in 1882, he started renting camping space to railroad construction laborers. Within a month of Arnolds Park becoming a stop, he was advertising rooms to rent in his home. This photograph shows the Arnold home before he constructed a dance hall pavilion and hotel nearby.

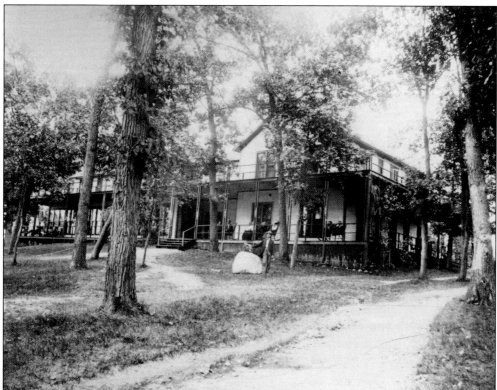

Situated within a grove of oak trees overlooking West Okoboji—and within clear sight of disembarking railroad passengers—the 1882 Arnolds Park Hotel was a popular lodging for those seeking relaxation or excitement. Built near the Arnold home, the hotel continued until 1939 when Howard Turnley demolished part of the hotel for a clearer view from the house, which his wife, Muriel, made into the Peacock Inn.

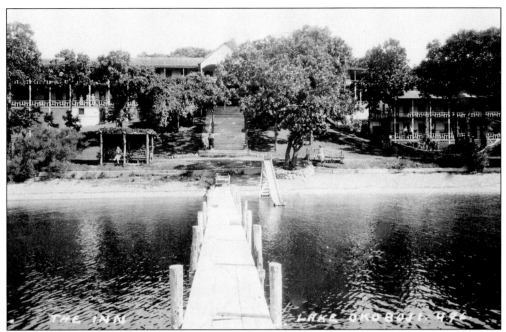

When introduced to West Okoboji, established hotelier J.A. Beck of Fairfield saw Dixon's Beach as an ideal location. In 1897, he put up a modest 24-room hotel and realized immediately it was not enough. The next year, he added more rooms, and for the 1899 season, the final bank of rooms was completed, each of which received cool breezes passing over the deepest part of West Okoboji.

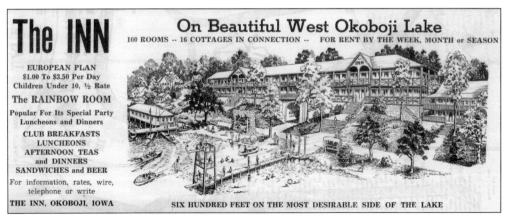

Sarah Callender and Mary Jacquith purchased the Inn in 1911, and the resort's reputation blossomed for years. Although seen as shabby by the 1930s, the Inn had nevertheless become a lakes area institution. A diving platform, dancing pavilion, steamboat dock, and popular golf course all added to the attraction. Callender's living quarters were destroyed in a 1944 fire, and the two women sold the property a year later.

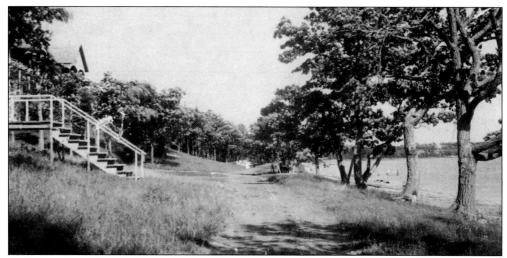

A pleasant path today affords a lakefront stroll on Dixon's Beach, but during the Inn's early days it functioned as the main road on this part of West Okoboji. This photograph from the hotel's first year of operation shows the dirt roadway. One could drive a carriage (or in later years, an automobile) under a large archway to reach this path.

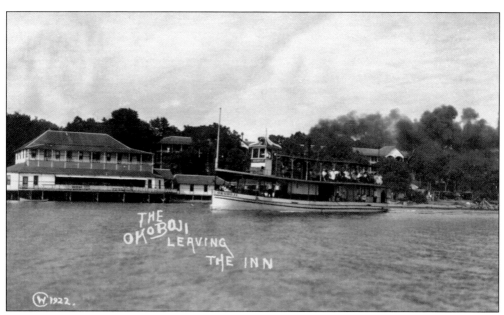

The Inn offered 100 rooms and cabins, and the resort also presented guests with dancing and refreshments at its lakefront ballroom, which was elevated to catch cool breezes. This 1922 photograph shows the *Okoboji* leaving the Inn, making it the last season for the aging steamboat. By the 1920s, an improved road behind the hotel offered easier access than steamers could provide.

Before the days of air-conditioning, hotels comforted their summer guests with cool breezes coming off the lake. The Inn was like other hotels in the area, with wide verandas, or porches, for people to sit in the shade. These natural gathering places also promoted socializing while watching children play in Okoboji's refreshing water.

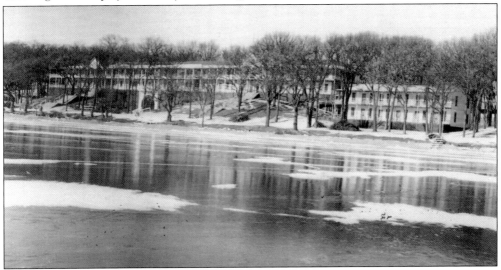

Though it was often obscured by shade trees during the summer, this winter photograph shows the extent of the Inn stretching along the pebbly shore of Dixon's Beach. Built using two natural bluffs for elevation, the Inn buildings shown here were razed in 1955 and replaced by the New Inn resort complex that featured modern rooms and amenities like air-conditioning and a swimming pool.

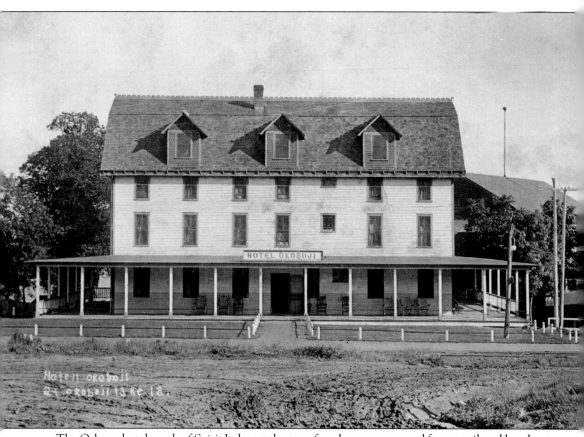

The Orleans hotel north of Spirit Lake set the tone for what was expected from a railroad hotel—a large, financially substantial investment that would draw visitors to town. If the BCR&N built one, then why not the Milwaukee Road? A railroad hotel at Arnolds Park was promised for two decades before it became a reality, and even then, it required private—rather than railroad—investment. Just a few steps from the Milwaukee Road depot, the hotel opened in 1902 with electric lights and was promised to be "modern in every way and [to] not fail to be popular with summer visitors," according to the *Spirit Lake Beacon*. Special excursion trains from Des Moines; Mason City; Sioux City; Sioux Falls, South Dakota; and Chamberlain, Nebraska, brought an estimated 3,000 people to the hotel's grand opening.

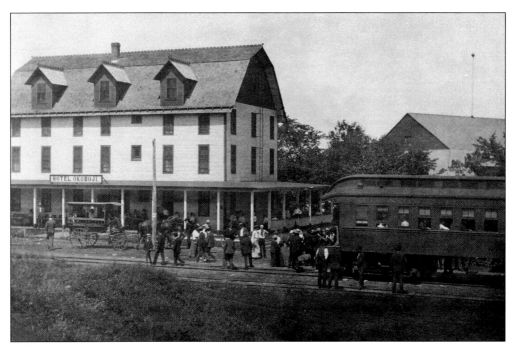

The height of modernity and convenience came together at the Milwaukee Road hotel, formally christened the Hotel Okoboji. Guests could exit the train and enter their rooms in just a few steps. Note the Central Ballroom dance hall immediately behind the railcar and the livery wagon from the nearby Arnolds Park Hotel.

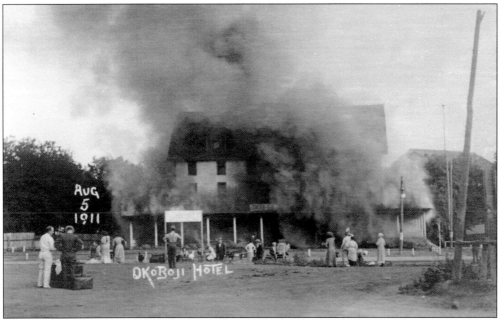

The Hotel Okoboji was in existence for just a few years before it was destroyed by fire in 1911. The blaze began in a basement storeroom and burned the structure to the ground in under an hour with no loss of life. News reports noted a bucket brigade was formed during the blaze to save both the depot and the adjacent Central Ballroom.

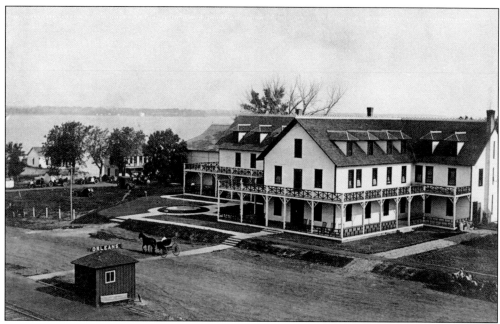

With the first Orleans hotel dismantled and the second and third destroyed by fires, a fourth was built on the grounds. This 1910 photograph illustrates the proximity of the hotel to the railroad, which had become the Rock Island line by this time. It was an era where horse and buggy shared the road with automobiles, which are visible along the spillway channel at the left.

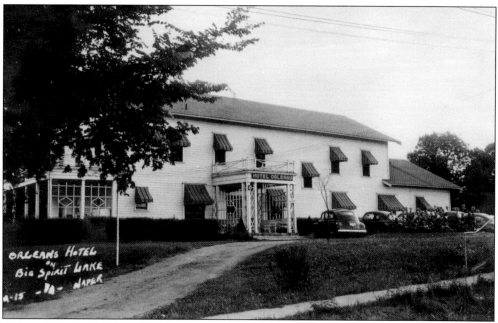

Although the final Orleans hotel was to hold a grand opening in July 1936, a fire that day doused those plans. Mabel Burnside rebuilt the structure with limited accommodations on the second floor. This 1937 building had become a modest affair, but it still sported a dance floor and dining room. The structure was made a private residence in 1967.

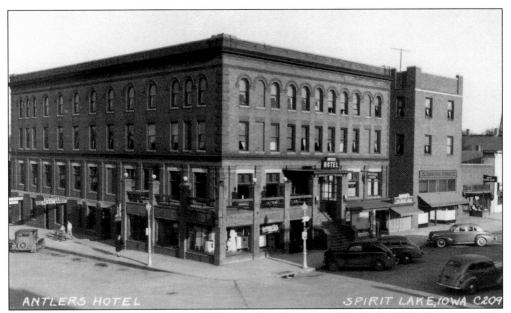

Built on the footprint of the old Crandall House hotel, Spirit Lake's Antlers Hotel was erected in 1902 to be a hub for the growing city. John Burmeister, who had rebuilt the Orleans hotel, planned the Antlers to be "a large, first-class modern hotel." The first guest signing the register was Iowa governor Albert B. Cummins, and a dinner party was held in his honor the opening night.

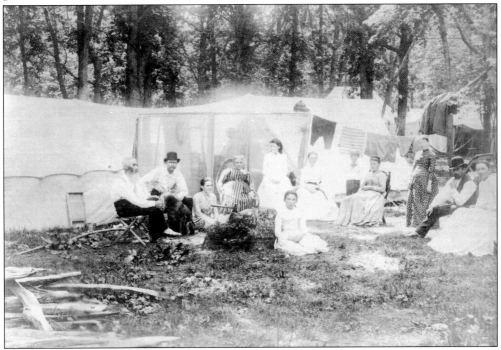

From its earliest days, Okoboji has been a gathering place for friends and families, even those of modest means and rugged taste. This group has set up camp, it is thought, on Pillsbury Point, bringing several tents as well as chairs and rope for drying laundry. Notice the hatchet in a tree stump and split rails—firewood, maybe—at lower left.

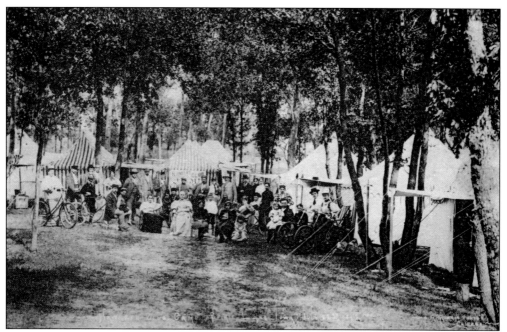

Although Dixon's Beach was a popular campground until development edged people out, the two main camping areas were Pillsbury Point on West Okoboji and Hawkeye Camp on Spirit Lake's south shore. Both camps had origins in frontier evangelistic speaking, but the camping lifestyle persisted well into the early 20th century. Hundreds would visit each year.

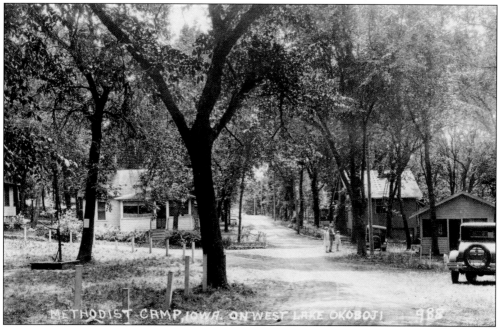

The Methodist Camp also had its origins in gatherings, stretching back to Reverend Pillsbury's talks on Pillsbury Point. Encampments were held in various locations around the lake until it was agreed in 1914 to build a permanent meeting place. Forty acres on the Brownell farm were selected, lots were platted, and enough were sold to pay off the entire price the next year.

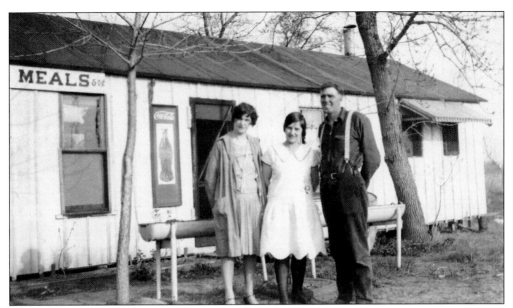

Although momentum was in West Okoboji, Big Spirit Lake had its early cabins and resorts, like the Sandbar Beach Resort, which was established in 1905 and run for many years by the Omer family. This photograph from about 1930 shows, from left to right, visitors Jessie, Ness, and Mark Omer in front of the resort's store, which also prepared meals for fishermen. It still stands, barely changed, today.

Offering itself as "a particular place for particular people," the Gateswood cottages were developed by Olus Gates and operated for many years by the Gates and Gardner families. The cottages featured electricity and their own water and sewer system. An eating place was provided for guests, as was a private police force. Gateswood is now part of the Fillenwarth Beach complex.

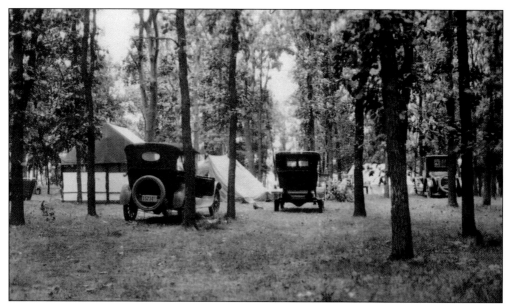

One of the last popular rustic camping grounds was Wheeler's Woods, on property bought in 1900 by George and Ella Wheeler near present-day Maywood. The first camps began in 1911, and as the photograph above shows, campers were now arriving by automobile. Encampments were permitted through the 1940s and beyond, even though cottages had been added. Below, going camping means going without modern conveniences, like running water and automatic washing machines. When it was washing day, the smart thing to do was to don bathing attire and take one's clothing to the lake, as this family is doing. This image is probably from about 1925. Part of the property is now preserved as the Wheeler Heritage Woods.

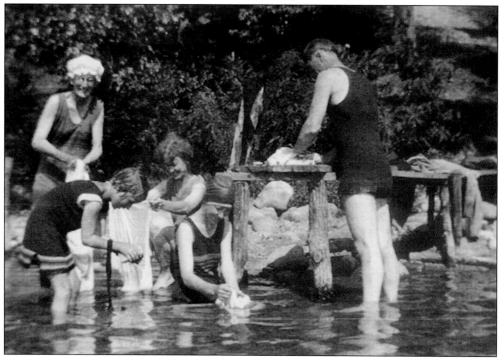

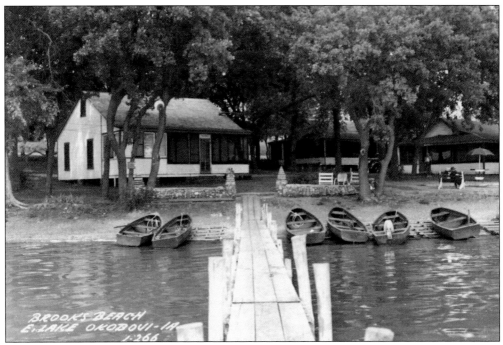

The Brooks Resort on East Okoboji was started about 1920 by Melford Brooks and was operated for many years by his son, Val Brooks, who also built Brooks National Golf Course across Highway 71, and then Melford's grandson Bud Brooks. The Brooks cabins all front East Okoboji on what was known then as Sioux City Beach and have a natural sand beach. At one time, guests could play miniature golf on a course, built in 1935. The rear view shows how close the cabins were to the railroad. This must have been a disruption that one could only embrace, as Milwaukee Road trains came through several times a day.

Spirit Lake has a positive reputation among fishermen. This photograph from about 1930 shows a group at Sandbar Beach resort with fishing gear. Mark Omer is on the left, and resort operator Pete Omer is likely among the group of other, unidentified men. Fishing cabins at that time were largely simple affairs by today's standards. The automobile at left shows that passable roads had been constructed by this time.

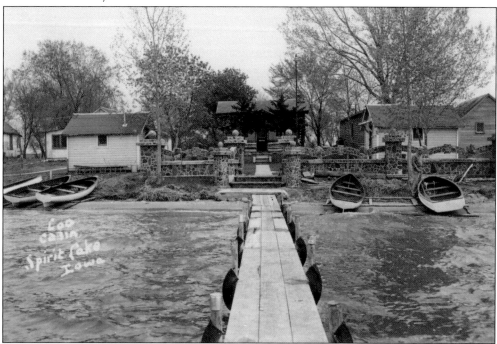

The Log Cabin Resort on Spirit Lake was a typical small, family-owned resort that Franklin Fedderson built in 1946. The extravagant stonework in front was not only an attention-getting device—it also helped identify the cottages on shore when fishing on the large lake. This undated postcard may date from Fedderson's first season of operation.

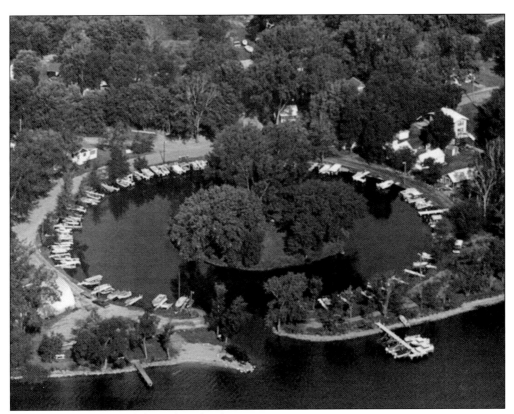

Lazy Lagoon was part of the Triboji development by the Percival family and the *Sioux City Tribune*, which helped promote investment in the property beginning in 1928. The lagoon was dug as a shelter for boats during rough weather. Businessman Alex Percival had established a campground, Northwoods Park, in the 1920s, which became Triboji. Under private ownership, Lazy Lagoon has been a resort, a marina, and boat livery.

Resort operator Esther Raebel is shown in the late 1930s at the family-owned Raebel's Resort on West Okoboji. In December 1944, her husband, Rob, was fatally shot and Esther was beaten by a former employee and his father. Henry Heincy and his father, Phillip, were arrested weeks later and convicted. Esther recovered but sold the resort to Gerk Jansen only three months later.

In 1945, Gerk Jansen bought Raebel's Resort and operated it for 30 years. Typical of mom-and-pop resorts, it featured 18 simple cabins on Estherville Beach, offering cool breezes, family-centered activities, and a playground for children. It is the site today of the Landings housing development.

A.T. Fillenwarth, having bought lakefront land in Arnolds Park in 1919, quickly realized people would happily pay to rent his simple cottage. He built more, acquired a few, and had 36 available for guests by 1930. The Fillenwarth family has continued the family business to this day, now operating as Fillenwarth Beach resort in Arnolds Park.

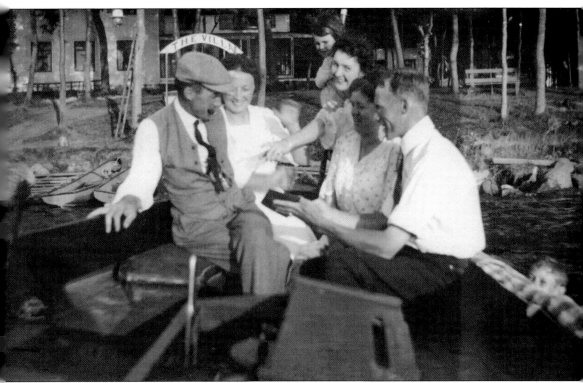

Originally named Lynhurst when built in 1885 by Col. S.S. Curtis, the large and extravagantly furnished home seen here was maintained by Curtis's daughters, Lynda and Carita. At the time of its construction, there was nothing of note but woods between the Milwaukee Road depot in Arnolds Park and the Okoboji grade. Marlin Goltry purchased the home in 1909 and leased it to Charlie Gibson, who established "the Villa" name and its fine reputation for vacationers in the summertime and hunters, fishermen, and trappers the rest of the year. The Villa remained in operation as a rooming house through the 1960s, with Blanche Goltry as the owner. She died in 1968. Arnolds Park's Carita Street is named after Carita Goltry; it leads to the Villa's former location.

Ideally located next to the grade at Okoboji and overlooking Smith's Bay, Smith's Cottages were the second career of Kate M. Smith, daughter of settler and Dickinson County historian R.A. Smith. A teacher by trade, she retired and then operated the cottages until her death in 1935, when other family members took over. The undated map below, probably from the 1940s, shows there were a dozen cabins, plus laundry, a playground, and then-new camping trailers. The original Smith home in the center still stands today. Smith Cottages and Campers succeeded this and eventually grew to be Smith's RV.

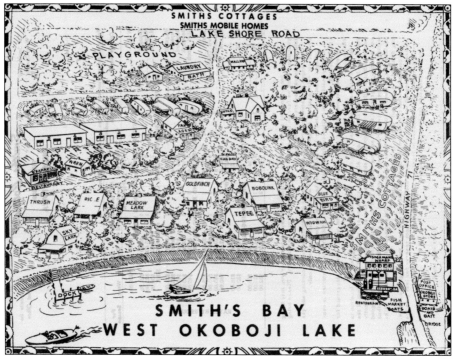

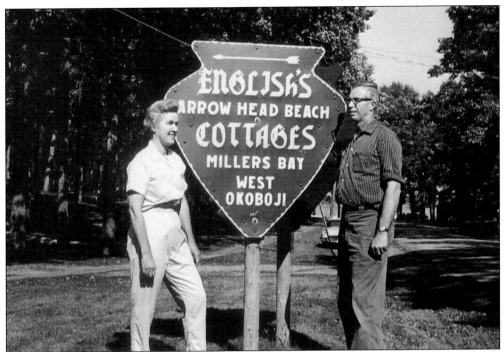

English's Arrowhead Beach Cottages were started as a late-in-life career for Arline and Wally English—not uncommon for resorts in the area. Wally had been a radio engineer and then a cattle farmer, but his family had vacationed at Okoboji for years at Karzin's Camp Illini on Miller's Bay. They bought lots next door in 1951 and added a total of nine cottages to the business in their 36-year tenure.

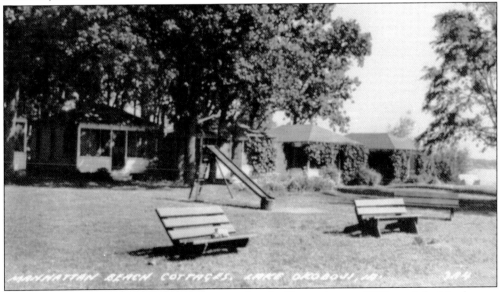

The days of grand resorts were coming to an end in the Depression-era 1930s, and the Manhattan Resort had suffered more than most. The hotel and ballroom over the sandbar were demolished in 1933, and the lumber was used to construct cottages. Buildings in the new cottage colony featured fireplaces, and guests had playgrounds, a clubhouse, and the point's beach for entertainment.

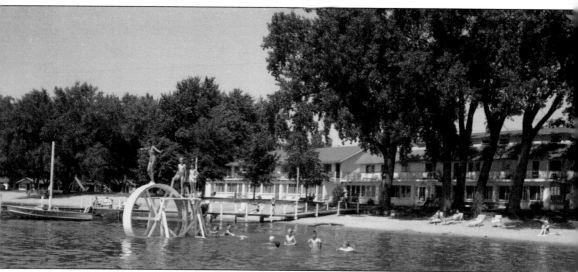

Crescent Beach was once the focal point of Lakewood Park, an "American Venice" financed by J.A. Beck (of the Inn) and H.E. Mills. In 1911, dredging began for 8- to 12-foot-deep channels, which were to connect Emerson Bay with Miller's Bay. Rustic bridges and cottages were planned throughout. Buyers failed to purchase the 500 lots, and by 1916, J.A. Beck had sold out to speculators. The Crescent Beach hotel was enlarged and remodeled with cottages, and traditional motel rooms were added over the next few decades. Even as late as the 1930s, the resort remained a quiet, out-of-the-way beach. Investment after World War II saw Crescent Beach Resort grow along with the postwar optimism—and the baby boom that followed. It was owned by Carroll Lane during this growth period. This 1950s-era photograph shows the resort's famous waterwheel that entertained children for many summers.

Four

COTTAGE LIFE

Few things in life held more promise than an entire summer at Okoboji. Opportunities for excitement or solitude could be had in equal measure. Over the decades, what often began as a tent pitched on the lakeshore evolved into a humble fishing house and perhaps to a three-season home with a guest bedroom—after all, what is the purpose of having a lake house if friends and relatives cannot visit on a warm summer day? In the early days, families would spend three months or more at the Iowa Great Lakes, bookended by opening and closing their cottages. At a time when people were more formally social than today, dancing and card-playing often complemented fishing, water sports, dinners, and luncheons. Lakefront cottages have grown grander and more modern, but the desire for enjoying oneself has not.

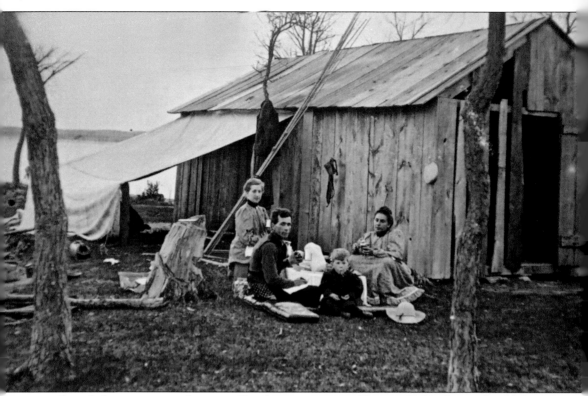

Spirit Lake engineer, machinist, and hardware store owner Clarence Hill had a comfortable house in town, but given the era into which he was born (in 1876), the outdoor life apparently called to him. As a young family man, Hill preferred to camp with his family in this primitive lakefront cabin, a popular diversion at the time known as rusticating—partaking of the rustic lifestyle. Cooking was over an open campfire, and dining was in the open air, picnic style. Fishing was obviously important to the family as shown by the half dozen or so bamboo cane poles leaning against the structure. Shown here are Bertha Mae Williamz (left), wife of photographer L.F. Williamz, C.B. Hill, Laura Klein Hill, and their son Herschel in about 1905. In later years, Herschel went on to become owner of the *Queen* steamer. (Courtesy of Dickinson County Historical Society)

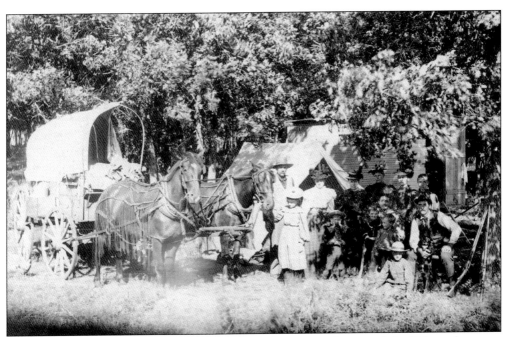

Not all enjoyed primitive living. This photograph shows an early view of the Colman house on Gilley's Beach, and while a full complement of camping gear is present, including a tent and Conestoga-style cook wagon, a small cabin is visible in the background. Note the shotguns leaning against the tree. At one time, game was plentiful, and it was common to hunt for meals or fish in the lake.

This photograph, identified as Bascom Landing, shows William H. Bascom's lodge on Lake Minnewashta in about 1898. The extended family has assembled in front of their substantial cottage. Tents used for outdoor sleeping were common; owners often camped until a cottage could be constructed. It is suspected this scene is along present-day Bascom Street in Arnolds Park.

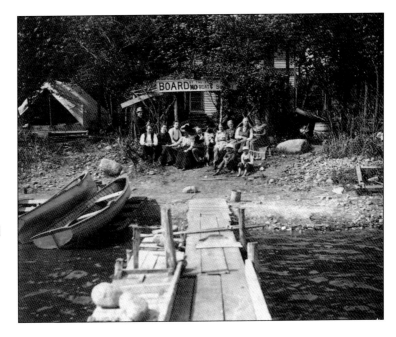

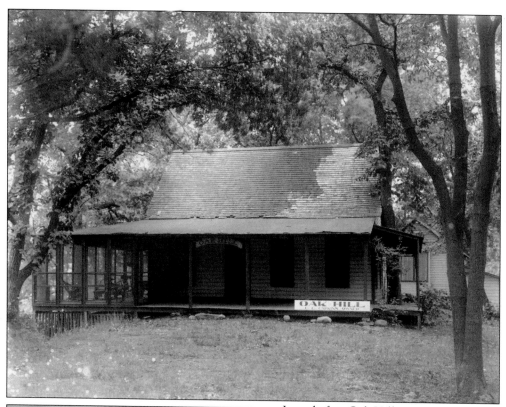

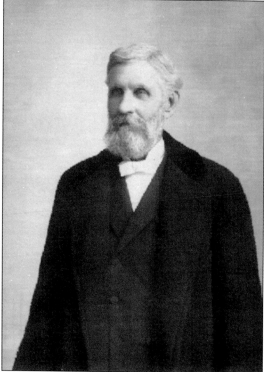

Long before Oak Hill was a marina, a restaurant, a gas station, or even a small resort, Oak Hill was a tidy cottage located on Minnewashta's Plum Ridge. Built about 1897 by a Mr. Wooley, Oak Hill was either alternatively inhabited or rented by C.C. Calkins through the 1920s.

The first private vacation cottage built in Okoboji was Seven Gables by George Dimmitt, but one completed just afterward gave the lake notoriety. Residents and vacationers alike knew well-respected Iowa Supreme Court judge Josiah Given's 1886 cottage on Des Moines Beach. The reputation of Judge Given (pictured) so great, the nearby point was named Given's Point. But for him, the spit of land could have been named Dimmitt's Point.

For late-1880s vacationers seeking to own lakefront on West Okoboji, Des Moines Beach—offering cool breezes and spectacular sunsets—was the place to invest. Early residents established the convention of encouraging others to ramble on the grassy shoreline. This rustic bridge over a gully was often photographed. The gully has since been filled in and the bridge removed.

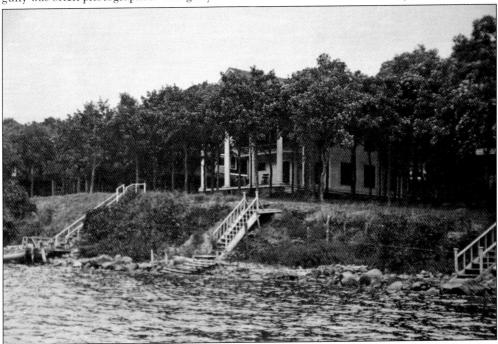

Okoboji cottages soon became more than just weekend getaways, as those with wealth used their properties to make statements. This striking cottage, built by real estate developer and banker John Q. Adams about 1900, was fitted for year-round habitation. Said to be "elegantly finished and furnished" with all modern conveniences, the mansion burned to the ground in September 1915, taking two adjacent cottages with it.

With the expanse of West Okoboji for a background, lots around Fort Dodge Point were readily developed. In this case, a number of families from Fort Dodge were original purchasers, hence the name. In 1892, the *Fort Dodge Messenger* reported "the Fort Dodge people are talking of taking their flight for Fort Dodge Point [at] Okoboji about July 1st." In the days before city water, the windmill pumped a well.

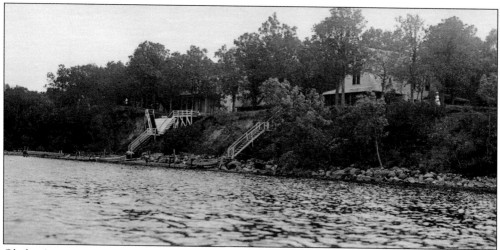

Okoboji's cottages evolved from simple shacks to sometimes large and ornate creations, and by the 1920s, they were often constructed to accommodate (nearly) year-round occupation. With a double staircase leading down to the water and a dock, Bayview Cottage in Miller's Bay cut an impressive image to boaters.

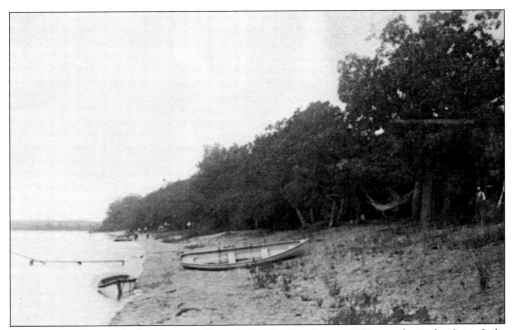

Early on, campers staked a claim on Dixon's Beach. An August 1889 article in the *Spirit Lake Beacon* notes that "Dixon's Beach is at once the most beautiful and popular of them all, there being at all times during the season from 125 to 150 tents, and this year a chapel is built in which services are held each Sunday." The land was platted for development not long after this.

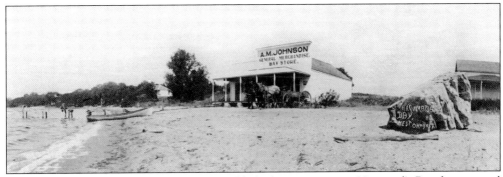

Spirit Lake store owner A.M. Johnson established an outpost on Hayward's Bay for seasonal residents that also functioned as a post office for the area. Johnson also maintained a nearby cottage for many years. This photograph from about 1911 shows the bay's broad, sandy beach. The boulder on the right was a notable landmark. Although toppled and largely covered by sand, the boulder still rests on the beach.

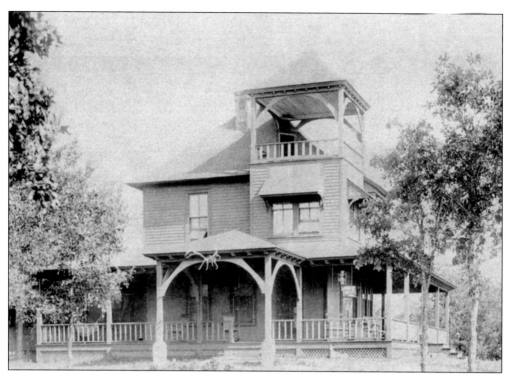

Wealthy Sioux City businessman Gordon R. Badgerow visited Okoboji on many occasions and in 1884 began searching for a suitable location for a cottage. By 1889, he bought a lakeside farm and had erected this impressive cottage, Egralharve, by 1896. The land was known for its natural mineral spring.

The stretch of West Okoboji shoreline today known as Egralharve was named after Gordon Badgerow's three sons—Egbert, Ralph, and Harve Badgerow. Although not identified specifically, it is believed they are shown here with their mother, Adelia Badgerow, about 1935. Successful from real estate and lumber interests, Gordon Badgerow died in Tacoma, Washington, in 1916.

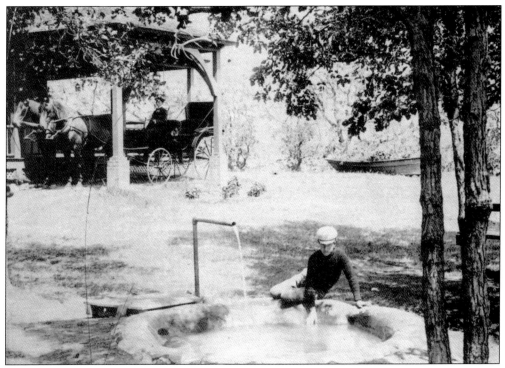

The mineral spring at Egralharve was known to early settlers and Indians as Mini-do-ka, and its medicinal properties were respected. The Badgerow family saw that this water should be bottled and distributed and in 1912 began the Egralharve Mineral Springs Company, which closed in 1933. The water was piped a half mile from its source to the Egralharve cottage and bottling plant.

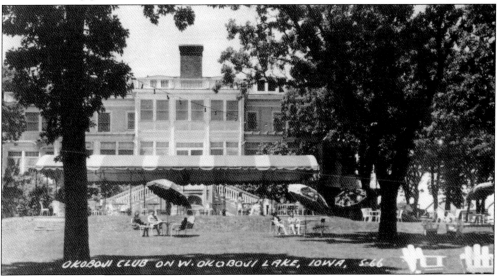

The grandest cottage ever on the lakes was the Floete Mansion, built in 1917 by lumber millionaire Franklin Floete. Prominent on Miller's Bay with "more than 100 rooms including closets and toilets, etc." (actual number was 32) and 15 fireplaces, it was offered as a summer home to Calvin Coolidge, but he declined. Investors purchased the long-unoccupied mansion in 1945 to form the Okoboji Club. It burned in 1951.

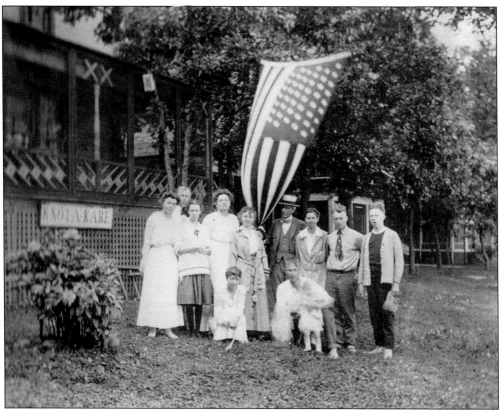

About 1902, the C.J. Wohlenberg family of Holstein observed Independence Day like everyone else, by gathering friends and family to their cottage at Okoboji. Born in Germany in 1860, Wohlenberg became a prominent banker, dying in 1943. The 45-star flag (above) was in use between 1898 and 1908. In an earlier 1900 photograph, the Wohlenbergs and friends enjoy a laugh, possibly at the expense of the young boy holding a pole (below, second from left). The Knot-A-Kare cottage on Haywards Bay has stayed within the family and has been remodeled slightly over the years, with the porch enclosed and a pebble-dash stucco finish applied to the exterior. The young boy in front on the right is likely Carl C. Wohlenberg, father of the current owner. Note the Buster Brown suit on his companion, stylish for young boys in the day.

Over time, a growing middle class resulted in widespread building of smaller, but tidy, modern cottages like this bungalow. Often built directly on the ground or supported by blocks or boulders, hundreds of these simple structures were built around the area. By the 1930s, both city water and sanitary sewers began circling the lakes. Many such cottages are still in use today, remodeled as private year-round residences or weekend getaway homes.

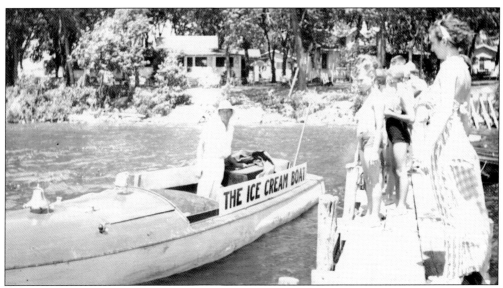

Few things are as refreshing on a hot summer day as an ice-cream cone. Entrepreneurs like Ike Morisky found a unique way to meet consumer demand with an Ice Cream Boat. Every summer, vendors would distribute flags for people to wave and attract a frozen treat, although waving a white towel would draw summer refreshment to a dock as well.

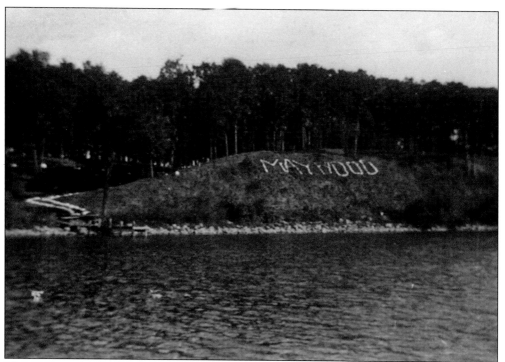

Maywood was developed in 1920 by banker and department store owner J.F. May and C.T. Stevens of Milford. Cobblestone pillars still mark the entrances to the tract, which was carved out of a 40-acre woodland. Lakeshore lots sold early, but others featured "wild outdoors with its primitive aspect" to appeal to those "not yet fortunate to own a bit of Iowa's most beautiful lakeshore."

As areas around the lake began to lose their unspoiled nature, residents were quick to adopt names to make them known places. Just south of Pillsbury Point lies Sunset Beach, and the name becomes obvious at the end of a summer day—it faces, nearly directly, the setting summer sun. Promoters of the land erected an attention-getting sign on the lakeshore.

70

Five

RECREATION AND WATER LIFE

From its earliest days, Okoboji's beautiful, clear blue water beckoned to visitors to swim, travel in canoes, rowboats, sailboats, fast boats and steamships, and enjoy themselves. Records indicate that as early as the 1860s, settlers and entrepreneurs marveled at the purity of the lakes, especially West Okoboji. The Okoboji Yacht Club is one of the oldest sailing organizations in the Midwest, encouraging youth to learn wind-driven piloting and pass those skills down to their children. Consider the number of youngsters over the years who first learned to swim at Okoboji, either off a dock or from one of the sandy beaches, or who were allowed to maneuver a powerboat all by themselves—a virtual rite of passage. Opening and closing a summer cottage were notable accomplishments for the entire family. Swimming attire may have evolved to today's lightweight and comparatively skimpy fashion statements, but the water has never changed. Swimming, boating, skiing, sailing, and the occasional kids' Boji bath—jumping in the water with a bar of soap—are all well documented through the years.

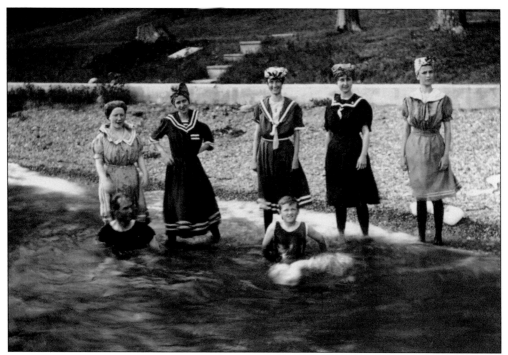

Dixon's Beach remains one of Okoboji's premier locations. Seasonal south breezes cool while passing over the deepest part of the lake, providing waves for bathers like this party. The broad, gravelly beach slopes gently downward and then descends to the lake's full 136-foot-deep hole. The cement wall behind the swimmers suggests this photograph was taken in front of the Inn; perhaps they are guests on vacation.

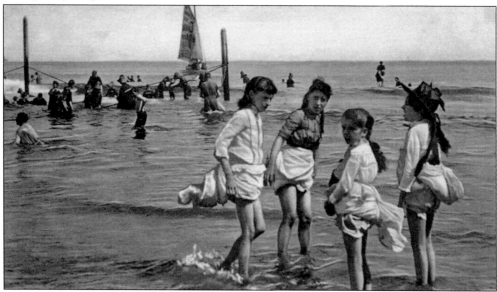

Four girls hike up their dresses and show their bloomers—an acceptable practice for children—while wading in Big Spirit Lake near Templar Park. Although built for conclaves of the Knights Templar, it also functioned as a resort for their families. This photograph was likely taken in the late 1890s when Spirit Lake's level was extremely low, affording bathers a long walk in shallow water.

This is the height of bathing attire in about 1912. Norine W. Crowe rests against a canoe while wearing bathing slippers and stockings, a modest bathing suit that covers from knees to shoulders, and a cap to protect her hair. Times were changing, and in just a few years, bathing garments above the knees would be commonplace. (Courtesy of Carl L. Wohlenberg.)

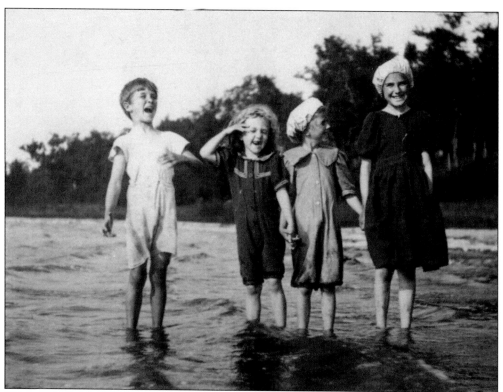

What fun it is in Okoboji in the summertime! The water is delightful at Okoboji, especially for a child wading along the beach, sharing a joke with friends. Over the years, more than a few children have splashed in the clear water or enjoyed a Boji bath off a dock.

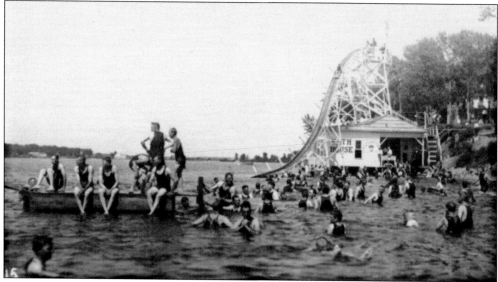

There is nothing like horsing around in the water at Okoboji—that's the way it is in this c. 1920 image and the way it remains today. These young men enjoy some summer fun at the Arnolds Park beach near the water toboggan slide. Note that men's fashionable swimwear at the time was basically a singlet that came up to the shoulders.

Water toboggan slides were enjoyable forms of entertainment for the brave as well as spectators. Over the years, water toboggan slides could be found at all the popular resorts around the lakes. This view, possibly from the Manhattan resort, shows the steamboat *Hiawatha* from a 60-foot-high vantage point.

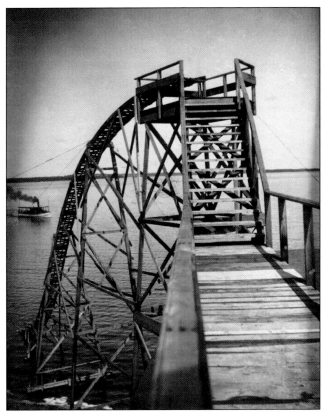

The low-water periods of the 1890s are evident in this view of Arnolds Park, Stevens Beach, and Pillsbury Point from the water toboggan tower. Passengers disembarking from the *Manhattan* walk by a sailboat and a launch while another steamer waits at a far dock. Visitors were able to rent rowboats to get on the water. Note the camping tents visible on Pillsbury Point, just above the sailboat.

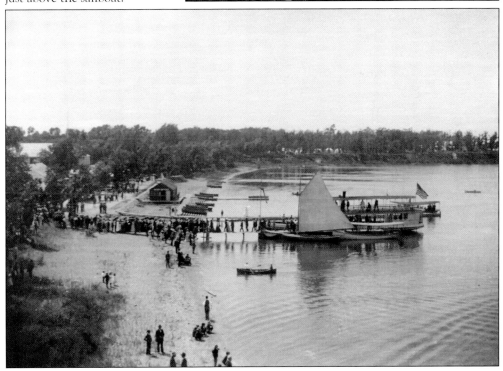

In addition to thrills and frivolity, Okoboji also offers moments of peaceful relaxation. This 1910-era view from the steps of the Villa hotel shows a placid Smith's Bay, Des Moines Beach, and Fort Dodge Point. At this time, the Villa's dock was one of few on the lake. Not many years before, the entire view would have been absent of cottages.

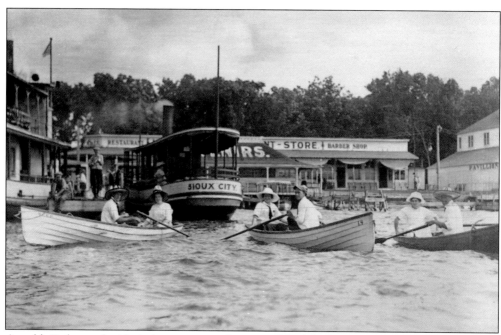

Arnolds Park was the ideal place to get on the water. The lakeshore was just steps away from the train, and one could board one of the steamers like the *Queen*, at left, or the *Sioux City*. One could also rent a rowboat and paddle around. Note that the Lakeside Department store also had a barbershop and restaurant. The Pavilion, at right, was a popular dance hall.

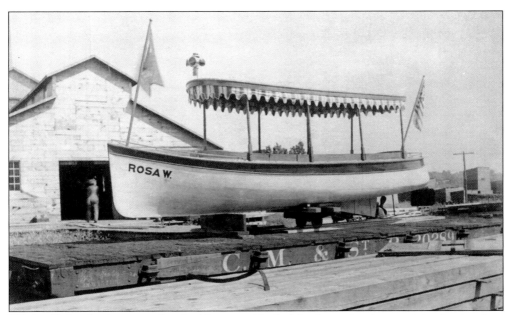

While Okoboji had its native boatbuilders, notably the Henderson brothers and the Arp brothers (and Spirit Lake had the Hafers), it was not unusual for some craft to be brought in. The *Rosa W.*, named after the wife of the boat's owner, was shipped by train from Des Moines about 1908. She was a gasoline-powered launch about 25 feet long with a stylish removable canopy.

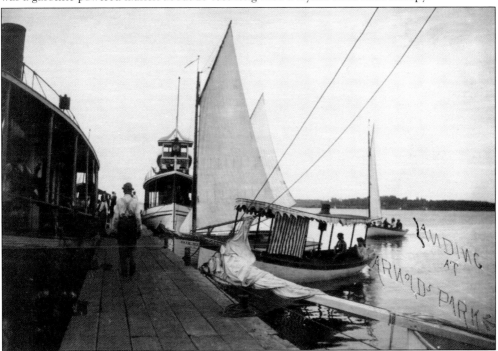

Boating has always been appealing, but with so few docks on the lake, boaters would put in wherever was convenient—even if it was used by the steamboat fleet. Here, a private launch and two sailboats are already tied up while a third approaches the landing. Based on the front navigation light on the *Okoboji*, this is about 1902.

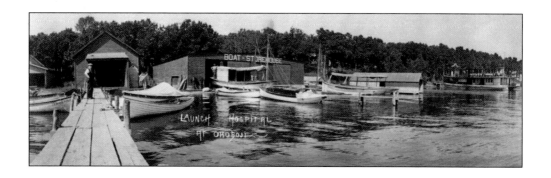

The site of the present Okoboji Boat Works has seen much boating history. The *Okoboji* was assembled on adjacent Given's Point, as were numerous other steamboats and launches. But with a growing number of launches—one enumeration conducted in 1901 counted 127 launches, 505 row oats, and 30 sailboats—a "launch hospital" was a going concern for Fred Roff. The photograph above is probably from around 1909. The property passed to noted boatbuilders the Arp Brothers in 1914 and Charles Gipner in 1940. By the early 1950s, when this aerial view was taken, the property had taken on an appearance familiar today as the Okoboji Boat Works.

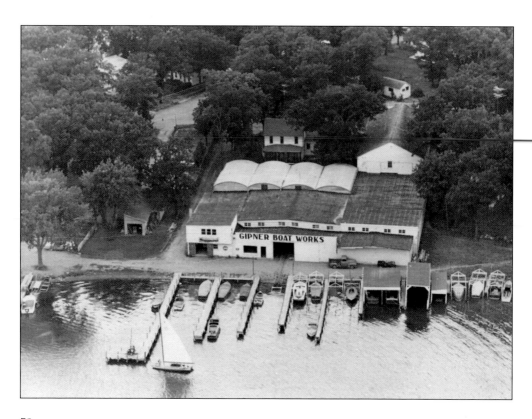

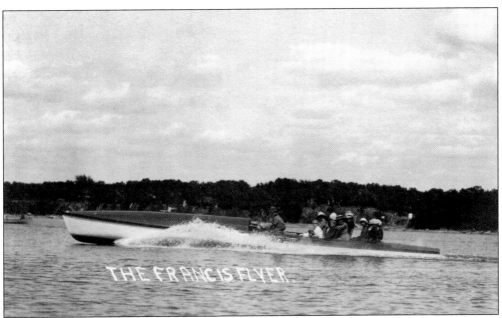

In 1906, no launch was more well known at Okoboji than the *Francis Flyer*, owned by Sen. L.E. Francis. A sleek and fast launch, the *Flyer* was a regular competitor in well-publicized races against C.F. Colcord's *Oklahoma* and W.A. McHenry's *Merry Mac*. The 40-foot-long, 80-horsepower *Flyer* was built by John Hafer in Spirit Lake. It left the lake in 1917.

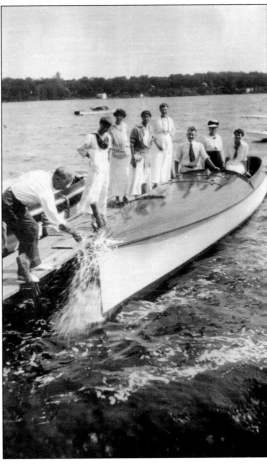

From the success of the *Francis Flyer*, John Hafer built similar boats for others on the lakes. This Hafer boat is being christened *Knot-A-Kare* about 1912, matching the name of the owner's new cottage on Hayward's Bay. Boats of this era typically provided a bench seat only for the operator. For passengers, stylish but lightweight wicker chairs were brought in.

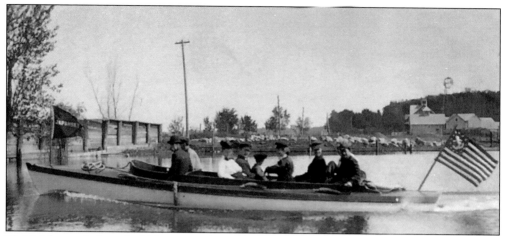

"A.M. Johnson Jr. launched his trim gas boat 'Japansky' Tuesday," reported the *Spirit Lake Beacon* in May 1905. "It is the envy of every lover of the perfect launch." That may be true, but Johnson sold the boat in 1907. "Speed, speed, speed is all the rage with the launch enthusiasts," the paper wrote. "Japansky" was the name of a character in the popular comic strip *The Kin-der-Kids*. (Courtesy of Dickinson County Historical Society.)

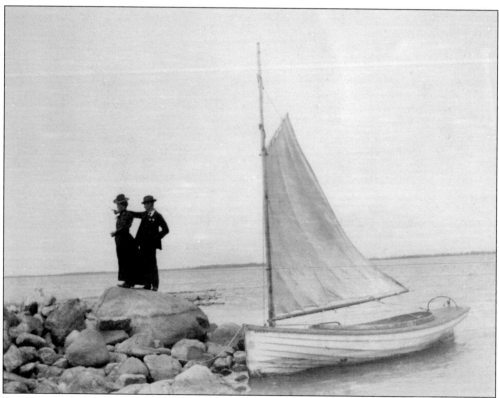

Boating was far less casual than it is today, as Dewitt and Carrie Peters demonstrate about 1899. Standing on Stony Point on the eastern shore of Spirit Lake affords a view of the entire lake. The Peterses lived in the area for 25 years before moving away in 1924. Dewitt held a variety of jobs in the area, including operating a hotel in nearby Superior.

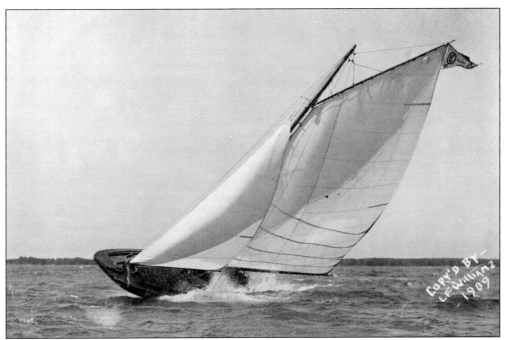

Sailing on West Okoboji has provided great sport since the founding of the Okoboji Yacht Club in 1877. Although the clubhouse location has changed—at one time, it was built over Pike's Point—the club has been in continuous existence since 1933. This 1909 photograph shows the triangular "OYC" burgee atop the sailboat's mast.

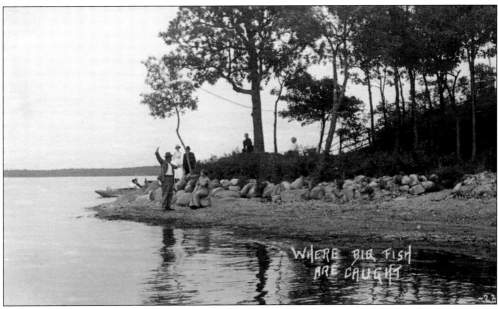

The one that got away has always been "this big," even in Okoboji's early days. Anglers have caught northern pike, walleye, perch, bluegill, and several species of bass. Fish have been so plentiful here that fear of overfishing was a real concern, and in 1880, a fish hatchery was approved by the state legislature.

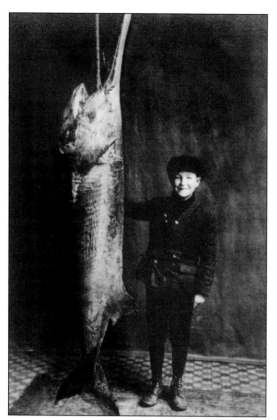

Species like this huge paddlefish thrilled anglers for decades. Paddlefish are river dwellers, and this one likely swam upstream until reaching the Okobojis. A dam erected at the base of Lower Gar in 1911 now means the once common fish are absent. While fearsome-looking from the long bill, paddlefish are slow and gentle, and they are often caught in rivers by snagging.

The Iowa Great Lakes' reputation for rewarding fishing was well earned. It was not uncommon for anglers to form fishing parties, sometimes chartering excursion trains to reach the lakes area. This group of happy anglers shows off the day's catch. The man second from left, wearing a pilot's cap from the steamer *Hiawatha*, is possibly J.C. Christiansen.

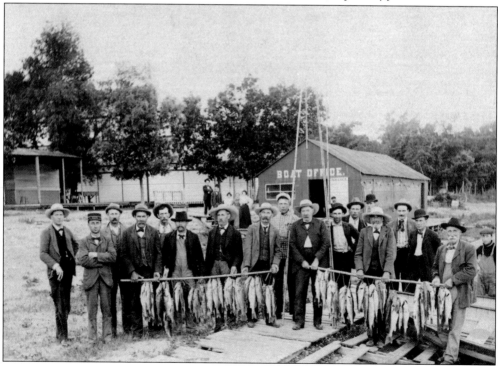

These men holding guns are likely competing in one of many shooting competitions for which the Iowa Great Lakes were known. One of the greatest trapshooters of all time was Fred "Dood" Gilbert of Spirit Lake, and sportsmen would come from miles around to see him shoot. Gilbert's talent was so keen he was dubbed "the Wizard of Spirit Lake." Gilbert Park was named after his death in 1925.

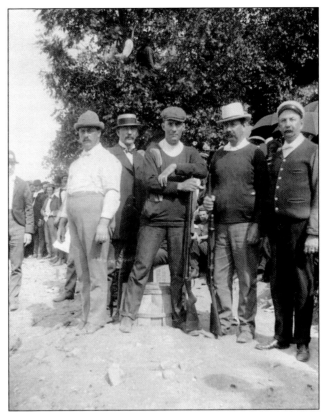

These five ladies and their daring launch operator pose for a photograph about 1898. The ride was no doubt thrilling, as the craft had a gasoline motor, something of a novelty. Visitors could check their baggage at the shop when enjoying all Okoboji had to offer. The buildings in the background are the Lakeside Store and the Arnolds Park Pavilion dance hall. (Courtesy of Dickinson County Historical Society.)

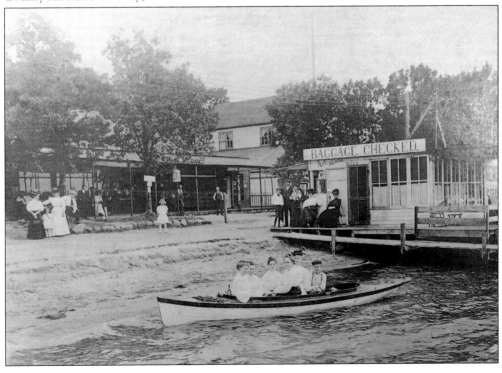

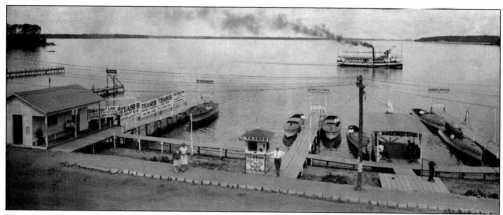

By the 1920s, speed was what thrill-seekers wanted, and boat operators delivered. The Eagle line operated the *Teaser* speedboat, with the craft's (claimed) 700-horsepower engine and mile-a-minute speed trumpeted as the "finest and fastest boat in the Midwest." High-speed rides began to lose their appeal following the 1929 disaster in which the *Miss Thriller* crashed with another thrill ride, the *Zipper* speedboat, killing nine.

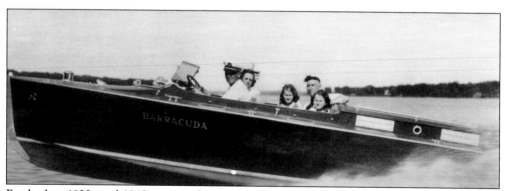

By the late 1930s and 1940s, private boat ownership became more common and charter boats had to stay one step ahead to lure customers. Giving one's craft an exotic name could catch attention. Here, a family enjoys a speedboat ride with an operator properly identified as the captain by his hat.

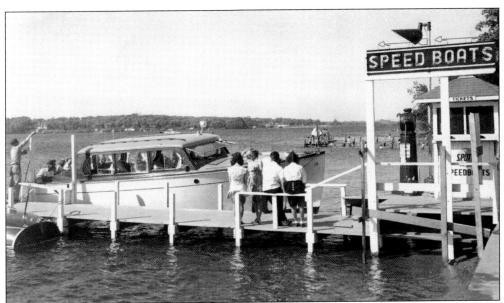

Into the 1950s, the pier at Arnolds Park was a busy place for boat operators. Frank Spotts operated a boat concession on the lake for years, as a speedboat operator, water taxi, and comfortable excursion boat operator with this 1940s-era cabin cruiser. Like today, visitors could get a tour of the lake.

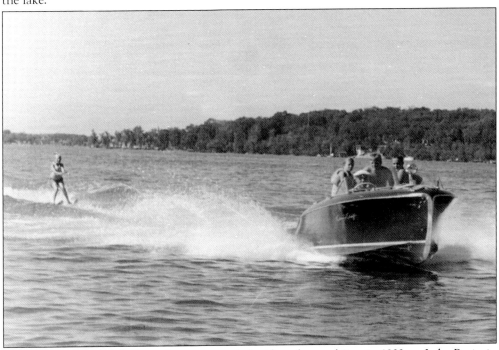

Eighteen-year-old Ralph Samuelson proposed the idea of waterskiing in 1922 on Lake Pepin in Minnesota, and it caught on among boaters in no time. As privately owned boats began to take over the lake, waterskiing—or aquaplaning on a homemade board—became a regular summertime activity. Here, an early-1950s Chris-Craft pulls a skier on West Okoboji while other youngsters enjoy the ride.

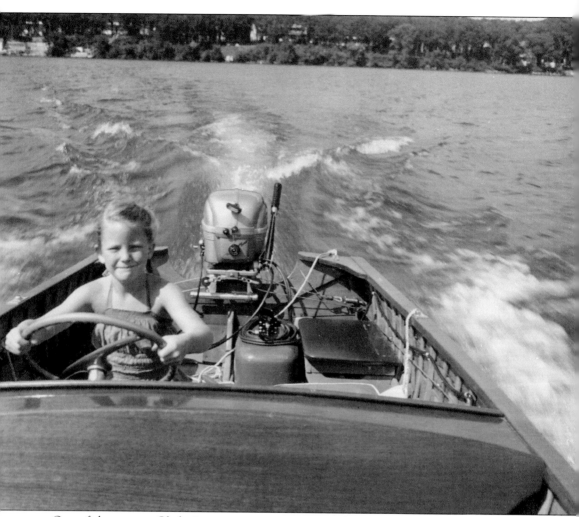

One of the reasons Okoboji memories are so strong with so many generations is that it is the location for so many firsts in life: learning to swim or ski, first fish caught, first ride on a roller coaster, first boat ride, a first flirtatious kiss—or first time operating a powerboat. Nancy Reed, about age six, is the model of concentration as she pilots her father's 15-foot Lyman outboard runabout in 1953. Today, children can be seen operating small personal watercraft in every part of the lake, but in earlier years, being allowed to take the wheel was a confirmed rite of passage.

Six

ARNOLDS PARK AND THE ROOF GARDEN

Would the lakes area be what it is today if, in 1889, W.B. Arnold had not erected a thrilling water toboggan ride on the lakeshore? For more than 125 years, what is now called the Arnolds Park Amusement Park has been the area's emotional and gravitational center for thrills, fun, culture, and courting. Over the decades, operators like Peck's on one side and Stevens on the other worked to both compete and cooperate with each other. The park has seen moving-picture arcades, dancing pavilions, roller coasters, and other rides come and go, along with not one but two roller-skating rinks. In days when dancing was a major part of socializing, the Roof Garden quickly became the engine for young people to mingle, fueled not only by regional acts, but also by nationally known orchestras, bands, and musicians. Ask anyone today—or decades ago, for that matter—what memories he or she has of Okoboji, and some aspect of the amusement parks at Arnolds Park will be central to those recollections.

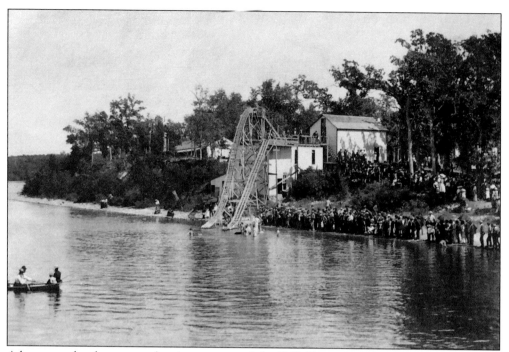

A large crowd gathers to watch goings-on around the 1889 Chute-the-Chute water toboggan slide at Arnolds Park, the first amusement ride built. Reaching more than 60 feet above the shoreline, a toboggan rider would hold on for dear life while plunging toward the water. News reports said the ride was "thrilling and not at all dangerous." When done correctly, the ride was exhilarating, with the toboggan skipping across the water for many yards. The photograph below shows the ride done poorly, with the "amature [sic] tobogganist" plunging to the bottom. W.B. Arnold also operated a bathhouse at the site. If visitors arrived at the lake without suits, they could stash their clothes in a basket and rent bathing suits for the day.

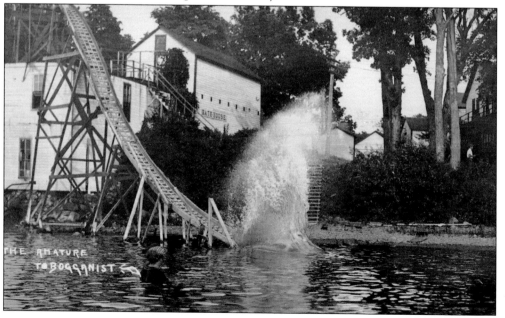

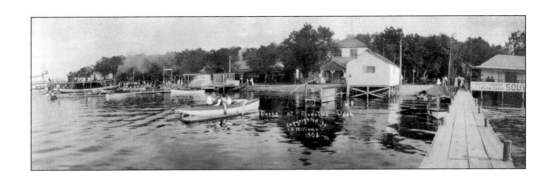

Above, this 1908 photograph of Arnolds Park shows the extent of activity typically found at the park: swimming, boat rentals, steamboat rides, souvenirs, dining, and dancing. Travelers could find nearly anything they needed at the park. This view is from the Stevens Beach side (later Benit's) and looks toward what is now Lake Street. Below, the 1922 aerial view shows buildings constructed over the water. (Some of the Stevens Beach overwater foundations are evident today.) At left, the carousel, Lakeside Department Store, and the Thriller roller coaster can be seen, along with a movie theater and funhouse. At right, Benit's Majestic Rink is shown along with other rides. The Legend roller coaster and State Pier have yet to be built. With baseball a national obsession, Arnolds Park was also the site of a baseball field.

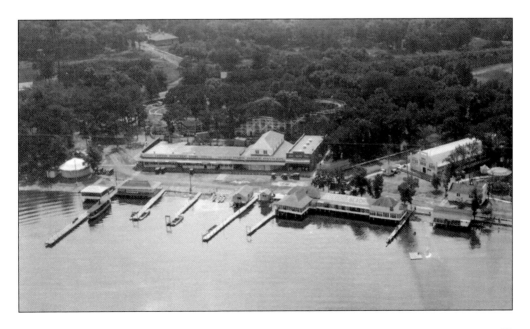

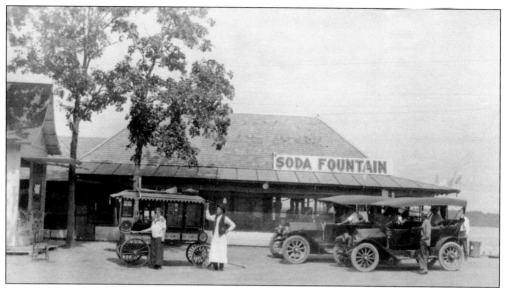

No trip to a vacation spot is complete without a cool drink over the water in the soda fountain and maybe some peanuts (center) or popcorn (at left). This image shows the Stevens Beach soda fountain as visitors would see it from Lake Street about 1920. Unlike today, vendors would rent space from the park operator and establish their own businesses.

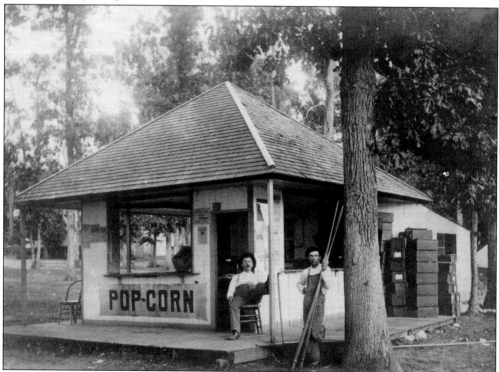

Sometimes, even Arnolds Park sees slow days. These unidentified men operating a popcorn concession at the park have time to relax and pose for the photographer. The dozens of wooden boxes at right likely hold beverage bottles, as cool drinks are a necessity for hot summer days. The man on right holds a set of oars, no doubt for a rowboat rental concession.

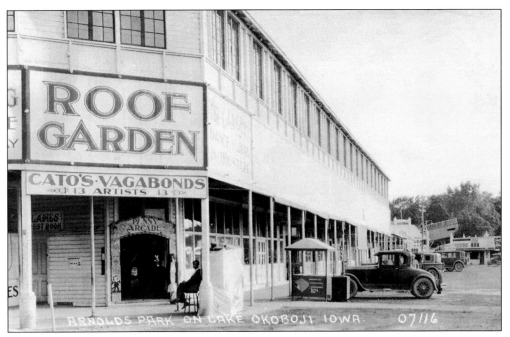

When the Lakeside Department Store began to outlive its usefulness, park owner Dr. A.L. Peck capitalized on the dance craze sweeping the nation. The Roof Garden ballroom was constructed atop the store in a little over six weeks, opening formally on June 23, 1923. Despite rain falling "in torrents" about 5:00 p.m., the opening night drew about 400 couples. By this 1930-era photograph, Cato and his Vagabonds became a frequent house band for dancers. Over the years, popular recording artists made appearances: Glenn Miller, Woody Herman, Sammy Kaye, and Lawrence Welk. In the 1950s, with dancing on its way out, operators switched over to rock-and-roll acts. The Lakeside Department Store was gone, but a penny arcade and other businesses had replaced it.

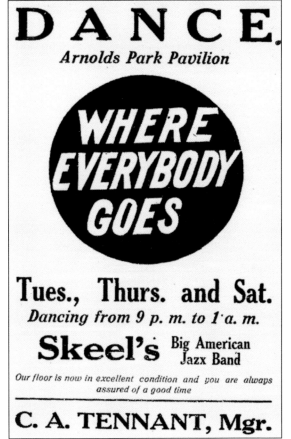

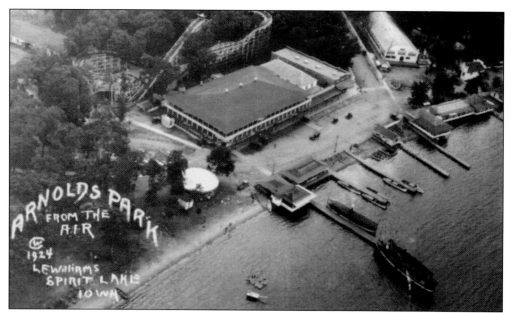

This 1924 aerial photograph shows the full expanse of the 100-by-162-foot Roof Garden, the "second largest hall in the U.S.," according to its owner. One also gets a good view of the Thriller roller coaster immediately behind the dance hall. At right, Benit's Majestic Rink is prominent. Note that at this time, structures built over the water were still permitted and launches were long and narrow.

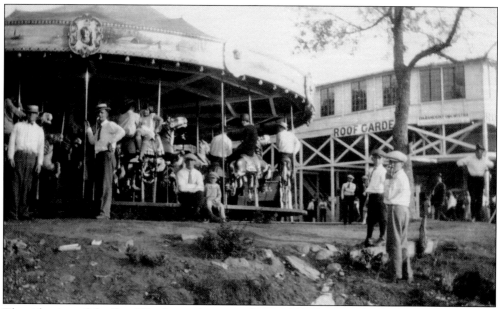

The side view of the Roof Garden is shown in this c. 1928 photograph of the carousel. On hot evenings, the expanse of windows around the building could be opened to catch a breeze and cool energetic dancers. The carousel had already been on the grounds in this location for about a decade and was a famous attraction for young and old.

This late-1930s image shows not just cars of the period driving around the east side of the Roof Garden (at right) but also signage for the Dreamland Roller Rink, Skooters bumper car rides, and popular eating place Carl's Cafe, selling Blatz Beer, one of the brews that made Milwaukee famous. It was considered "Milwaukee's Finest Beer."

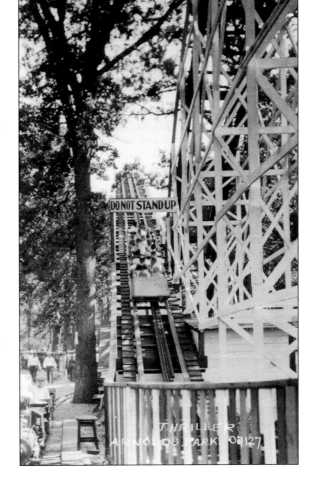

In a spectacular feat of one-upmanship, competing park owners C.P. Benit and A.L. Peck constructed roller coasters in 1930. The Thriller ride was 2,500 feet long and rose to a height of 73 feet before plunging riders downward. Painted red, white, and green, it was in operation until 1948. Famed coaster designer John Miller created both the Thriller and the Legend coaster that exists today.

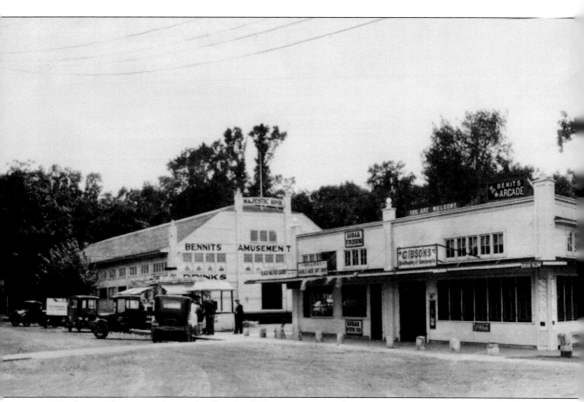

Built on what were formerly the shaded picnic grounds at Stevens Beach, the 50-by-144-foot Majestic Rink was ready for the 1919 season. News accounts said "one can get an idea of the magnificence of the building" even before it was opened. Notice that the sign painter misspelled the operator's name as "Bennit." The structure stands today as an events center, now named the Majestic Pavilion. The nearby "new Benit arcade" was constructed for the 1927 season and initially held a gift shop and pharmacy. Before long, it offered a snack bar and other businesses, including an ice-cream parlor operated by Charlie Gibson. The high-traffic corner became the longtime home of the Black Walnut Taffy Shop, started by Frank Lagios in 1919. Buying a bag of black walnut taffy quickly became an annual—if not weekly—event for visitors to Arnolds Park.

About 1928, Bud Jones, his nephew Gus and Gus's wife, Bessie, set up shop. (Of true Gypsy stock, the Stepanovich family came from Eastern Europe and changed their family name to Jones, hoping it would be easier to find work.) Word of higher-paying summer jobs brought them to Waterloo, Iowa, and at least seasonally to the amusement parks at the Iowa Great Lakes. All summer, the family camped in tents nearby—which certainly added to their mystique—and, before finally settling here, would return to Chicago in the autumn. Here, unidentified people wait to have their palms read. The banner behind them is on display at the Iowa Great Lakes Maritime Museum.

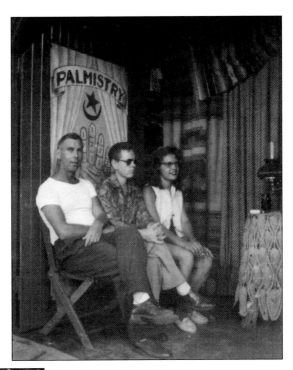

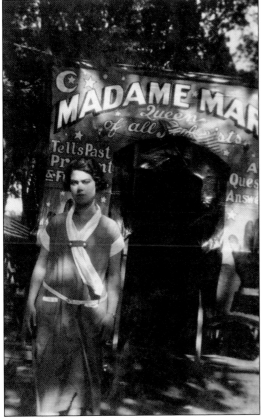

An amusement park would not be the same without a touch of barkers and hucksters to lend the appropriate carnivalesque atmosphere. One of the first was Madame Marie (left), who, in the 1910s and 1920s, had secured a fortune-telling concession at Arnolds Park and was widely known and much loved for her showmanship, if not her accuracy. But as the annual trips grew more difficult, she asked friends, the Jones family, if they would continue the business.

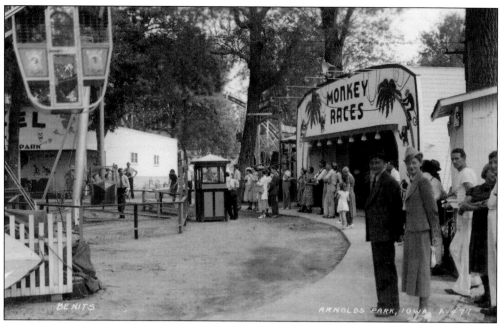

Arnolds Park, whether it was on Peck's side or Benit's side, offered excitement every way a person turned. The Pretzel was a "dark ride" where riders in a car were pulled along a track in the dark, twisting and turning like a pretzel. Amusement parks bought complete rides from the Pretzel Amusement Ride Company, which existed until 1979. The Monkey Races at right was a carnival-type game of skill.

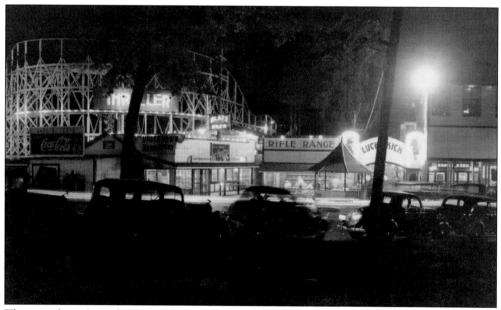

This view from the early 1940s shows the fun that could be had at night. The brilliantly lit Thriller sign, a rifle range, and Lucky Kick skill game all helped build an inviting carnival atmosphere. The Karmel Korn stand under the roof garden was a favorite. It was operated into the 1950s by William Weineke and Geraldine Touney of Mitchell, South Dakota.

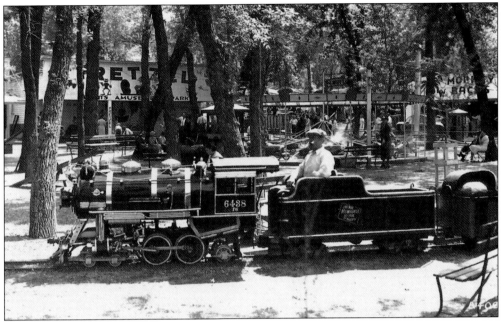

Youngsters of years ago were able to take a ride around the park on a real steam train. Longtime park concessionaire Homer Watson installed this model of a Milwaukee Road train, dubbed the Okoboji Limited, in 1931. Reportedly one of four such engines in the United States, the locomotive weighed more than 2,100 pounds and could pull 15 tons.

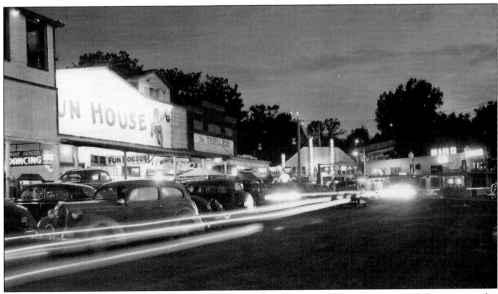

For many, this is everything Arnolds Park offers: bright neon lights, music, and dancing at the Roof Garden; the Fun House with its wooden slide and sugar bowl; the Thrill Ride and across Lake Street, the Hi-Ho Club; Majestic Rink; Tipsy House; and Benit's Midway. Unlike today, autos could circle the park all evening—uncounted numbers of couples have met and courted after "scooping the loop" at Arnolds Park.

97

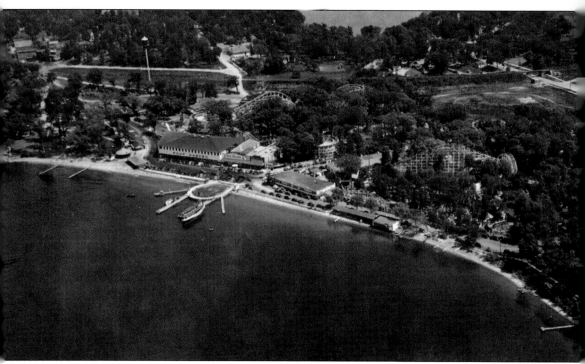

Compared with earlier views, this mid-1940s aerial image shows the changes occurring since the boom years of the 1920s. Near the beach, Peck's park still has the carousel, lakeside diner, Roof Garden and funhouse complex, but the rifle range, Lucky Kick, and other rides have been replaced. The Thriller coaster is still standing, but gone are the overwater shops and speedboat rides, replaced by the 1931 state pier with the *Queen* at dock. The baseball field by the railroad tracks and Highway 71 is all but abandoned. Nothing on this side remains today, replaced by Preservation Plaza green space, the Maritime Museum, Queens Court shopping, and parking. On Benit's side near the skating rink, the roller coaster is clearly visible. Over the years, it has been called the Giant Dips, the Speed Hound, and the Big Coaster, but today is dubbed the Legend. Other park rides are visible, as is Benit's Arcade. The days are numbered for the lakeshore buildings at right, which would be gone by the 1950s.

Seven

DINING AND VACATION BUSINESSES

Once railroad service began, it did not take long for tourism to become the lifeblood of the area—for the summer, at least. Wesley Arnold was among the first to take in visitors and began erecting facilities for day-trippers. Hotels and resorts like the Inn, the Orleans Hotel, and Manhattan were quickly joined by guest cabins, restaurants, diners, and attractions. Abbie Gardner Sharp's cabin and the 1895 monument to the Spirit Lake Massacre were among the most popular, but later, Harry Tennant's Kurio Kastle, dance halls, boat rides, roller-skating rinks, and moving-picture houses gained popularity. For certain generations, the place to eat was Red's in Arnolds Park or Tony's Italian in Milford. For others, it might have been the Peacock, the Inn, or the Antlers Hotel in Spirit Lake. In the hearts of those who enjoyed them, each made a splash then faded away over time.

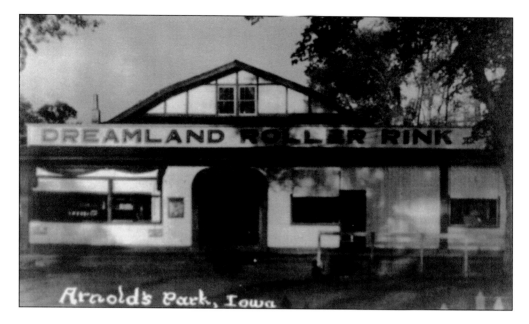

Dancing was always engaging, but a new form of social entertainment was catching on: roller-skating. The Dreamland skating rink was built in 1912 as an open-air tent pavilion. Often used for gatherings of all kinds where a large crowd was anticipated, it was moved to an enclosed building. With the park under new management in 1954, Dreamland was updated for year-round use as a dance pavilion. Fire leveled the building in December 1957. The 1919 Majestic Rink, below, was built with year-round use in mind, providing an entertainment opportunity for both local residents and seasonal vacation visitors. Even into the late 1970s, the Majestic Rink offered live music for skaters, first from bands and small orchestras and later from organists. The Majestic continued to be used as a roller-skating rink through 1987.

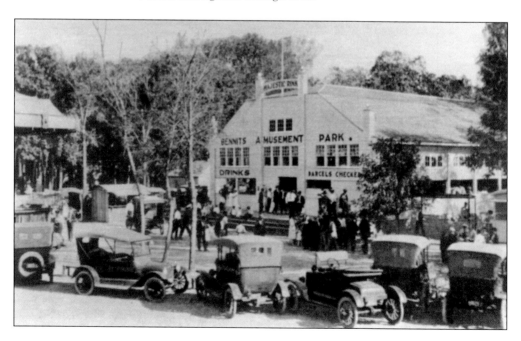

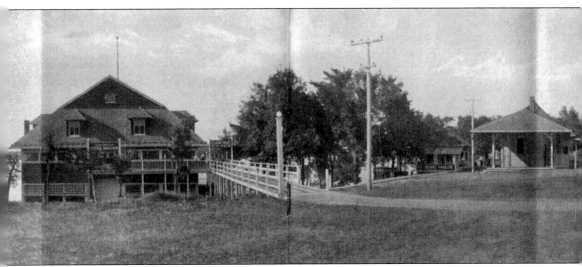

Built in 1901 with the adjacent (and ill-fated) Hotel Okoboji by the Walker family, the Okoboji Central Pavilion was spared from fiery destruction by a bucket brigade. A.F. Becker had just purchased the pavilion in 1910 and, by 1914, was promoting it as "the newest, largest, best built, best dance floor and by far the best looking of any and all on the lakes." Dance couples could arrive by train or boat. Made of brick and wood, the Central offered year-round dancing. Okoboji was a fashionable venue for dance bands to play; by the 1920s, there were several locations to choose from: the Central, Roof Garden and Casino ballrooms, while Manhattan, the Inn, and the Orleans on Spirit Lake all offered dancing in their pavilions and ballrooms. Bands and orchestras that played at the Roof Garden on weekends often performed at the Central on off nights.

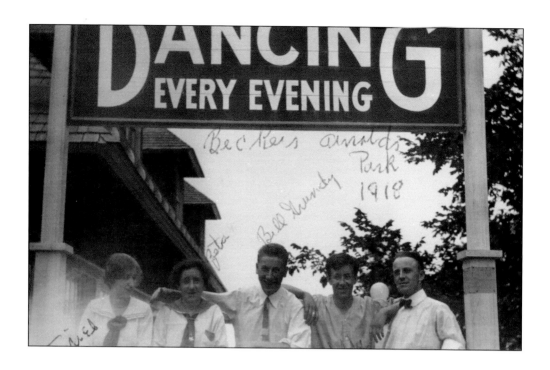

Dancing was a fun social event, as the happy friends pictured above show. At the Central Pavilion, one could dance every evening during the summer and most nights the rest of the year. The Central Pavilion in 1918 was owned by A.F. Becker. This photograph was taken at the entrance to the pavilion, which was reached by a boardwalk. The two stylishly dressed ladies at the left are Muriel Brooks and Zeta Brooks, whose father bought the land later known as Brooks Beach on East Okoboji. Below, this big band—actual recording artists—offered a cabinet card to remind dancers of the fun times in the Central Ballroom but encouraged traveling to Omaha during the off-season. Popular radio artists, the Tracy-Brown Orchestra also performed at the Casino Ballroom and other dance halls through the 1930s.

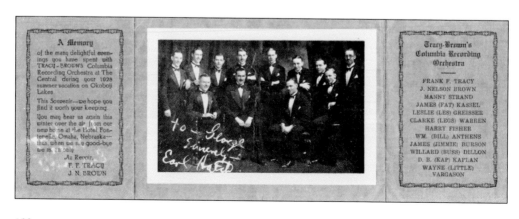

A Memory
of the many delightful evenings you have spent with TRACY-BROWN'S Columbia Recording Orchestra at The Central during your 1928 summer vacation on Okoboji Lakes.

This Souvenir—we hope you find it worth your keeping.

You may hear us again this winter over the air from our new home at the Hotel Fontenelle, Omaha, Nebraska—thus, when we say good-bye we mean only

Au Revoir,
F. F. TRACY
J. N. BROWN

Tracy-Brown's
Columbia Recording
Orchestra

FRANK F. TRACY
J. NELSON BROWN
MANNY STRAND
JAMES (FAT) KASSEL
LESLIE (LES) GREISSER
CLARKE (LEGS) WARREN
HARRY FISHER
WM. (BILL) ANTHENS
JAMES (JIMMIE) BURSON
WILLARD (BUSS) DILLON
D. B. (KAP) KAPLAN
WAYNE (LITTLE) VARGASON

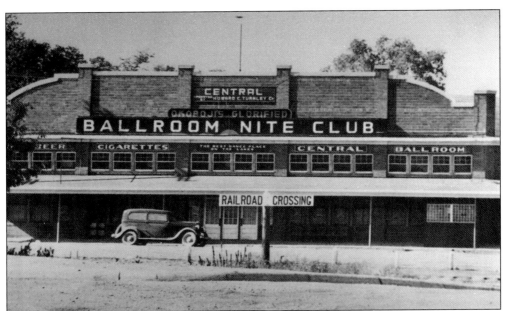

In the 1920s, authorities began enforcing laws that forbade dancing on Sundays. That did not stop enthusiastic promoters all over the lake from attracting dancers other nights of the week, however, with unique and attention-getting 41¢ admission and ladies free, instead of 10¢ a dance. Nor did it stop owners from enlarging Central's facility to its present configuration, now sporting a kitchen for refreshments and a dance floor inside the 240-by-80-foot building. And few establishments could compare. In 1941, Howard Turnley took over management from A.F. Becker, who wished to retire from the business. Turnley was manager of the nearby Roof Garden Ballroom in the park. He renamed it the Central Ballroom Nite Club to distinguish it from the park facility.

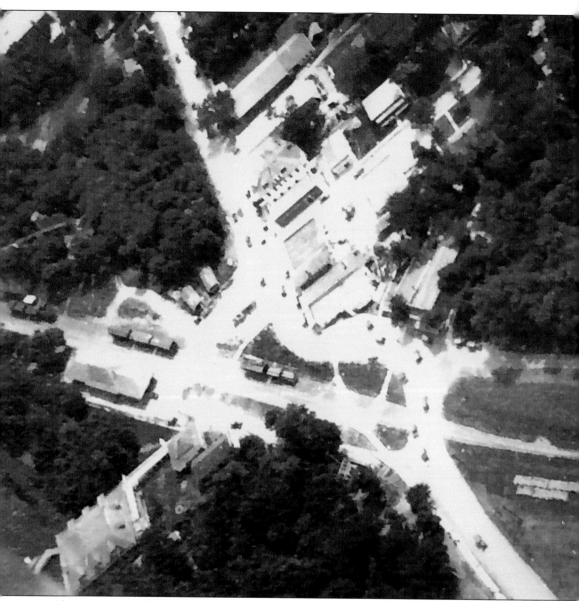

This unique aerial photograph—with a view looking nearly straight down—was taken in 1921 by L.F. Williamz, who called himself "the Yankee Fotographer." It shows the Central Ballroom at the bottom center with the boardwalk leading to it. At the end of the boardwalk is the square-shaped ice-cream shop that was constructed in place of the Hotel Okoboji that burned in 1911. To the left of the ice-cream shop is the Milwaukee station, with what look to be railcars along a siding. Today, that location would be the front of the upper West Oaks condominium buildings. Notice the cars on the S-shaped curve at the end of Broadway Street. This road crosses the tracks and leads to the amusement park to the right (not shown). That curve is the site of the Arnolds Perk coffeehouse, Wine Bar & Art Gallery, and Blue Water Studios, which had not yet been constructed. (Courtesy of Dickinson County Historical Society)

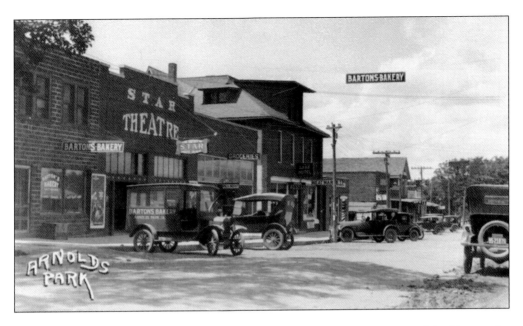

The view from the late 1920s above can be seen today by standing by the small building at the corner of Arnolds Park's Broadway Street at Allen Avenue and looking toward the amusement park. Arnolds Park had a thriving and diverse downtown district. The view shows Barton's Bakery with a delivery truck parked outside the Star Theatre—which at that time was still playing silent movies—a grocery store, barbershop, and the Lake Hotel rooming house. In the earlier 1918 view below, E.E. Chaplin's White Star Cafe is open for business. Chaplin's enterprise offered "meals and short orders. Open Day and Night. First class rooms. Auto Livery." Chaplin was once robbed at gunpoint during business hours, with the robber netting about four dollars.

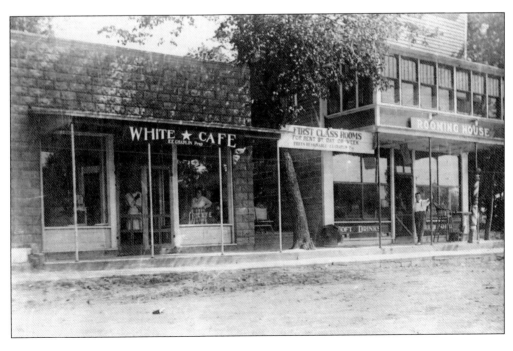

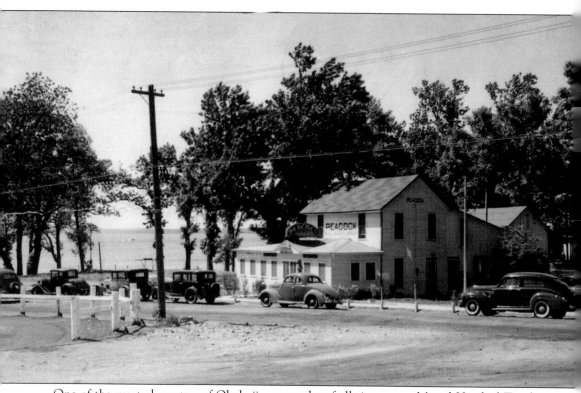

One of the great characters of Okoboji—or maybe of all time—was Muriel Hanford Turnley. Known as "the Peacock Girl" from Florenz Ziegfeld's 1912 Follies Show, Muriel performed in vaudeville until 1920. Born Muriel Window, she was married three times (her first two husbands were named Keane and Hanford) and arrested for at least as many liquor violations during and after Prohibition, and her professed motto was "You can't beat fun!" Muriel married Howard Turnley and moved to Arnolds Park in 1937, where she started the Peacock Tea Room in the W.B. Arnold house. It quickly became the Peacock Night Club and was famous for drinks, food, entertainment, and frivolity. The Turnleys sold the club in 1946, with the name remaining with new management, and she operated Muriel's Snack Bar for some time. Muriel made songs like "I'm Forever Blowing Bubbles" famous, and it was reportedly her image and name on the Muriel cigar packaging. A distinctive personality, she once sued her husband Howard for $10,000, which she felt was her share of two years' profits from his management of the Roof Garden. Muriel moved to Florida and died in 1965.

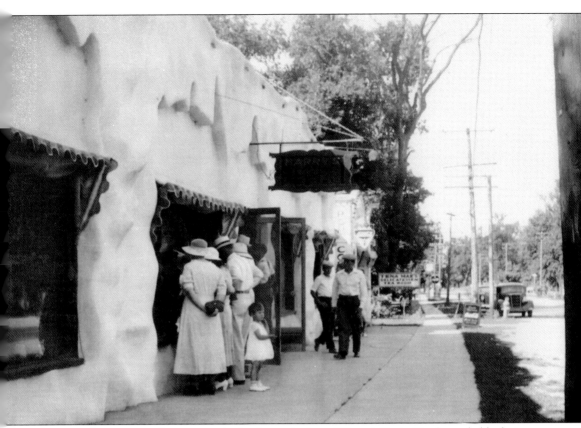

A group of curious people peers inside the front window of Harry's Kurio Kastle, probably during the opening week in 1933. Commercial fisherman, hunting and fishing guide, taxidermist, and entrepreneur, Harry Tennant had amassed a breathtaking collection of fish, birds, and other creatures, which he stuffed and mounted. Over the course of more than three decades, Tennant operated traveling fish seining crews around area lakes. In addition to fish, he also maintained a frog business, as frog legs were popular delicacy. His eye-catching Kurio Kastle architecture reflected his tastes, as does the Tennant Building housing his business offices a block away, which features unusual designs fashioned into the stucco. It is now part of Fillenwarth Beach Resort. Tennant worked at his Kurio Kastle novelty shop until shortly before his death in 1962 at age 84. Most of the specimens were placed in storage.

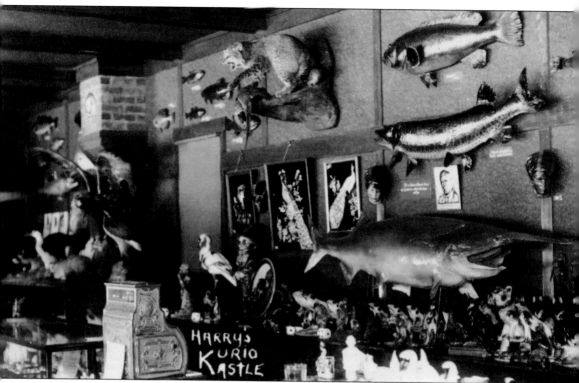

If ever there was a museum of oddities and curiosities at the Iowa Great Lakes, it could be found inside Harry's Kurio Kastle. Despite his catching and mounting thousands of fish over his seining career, perhaps the most famous of all is the 146-pound paddlefish from East Okoboji. This prehistoric-looking creature awed children and adults for decades while on display at the museum. Naturally river-dwellers, paddlefish could be found in East and West Okoboji, having come all the way upstream from the Missouri and Des Moines Rivers. When the museum closed in 1987, an accounting was made: 306 mounted fish, 30 game birds, 27 waterfowl, 23 owls, 22 cougars, wildcats, badgers, and other mammals, 18 shorebirds, 17 freshwater fish, 12 hawks, 9 wading birds, 9 songbirds, 5 eagles, and 5 reptiles. The museum also had a 1,400-pound trunk-back turtle, shells, coral, and several stringers of largemouth bass and walleye.

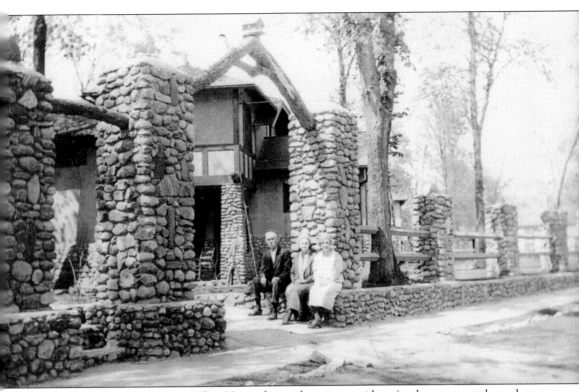

Known locally as the George Albro House from a longtime resident (and more recently as the Artsy Tartsy Salon), this unique building on Highway 71 has been a place for people to stop and get their photographs taken. Likely built to the specification of Harry Tennant, who owned the house through the 1940s, the masonry is the work of John L. Burgin of Milford, according to historian R. Aubrey LaFoy. Many of the stone pillars and foundations seen in the Iowa Great Lakes that use this distinctive vernacular architecture are from John Burgin and his son Ralph and son-in-law Guy Smith. Stones were collected from fields and lakeshores throughout the area and brought to jobsites as needed. Born in 1879, Burgin died in a sawmill accident in 1931. The pillars at the Albro House today have been shortened due to uneven settling, but originally, they reached over eight feet in height and had dual ranch rails between them, as seen in the photograph.

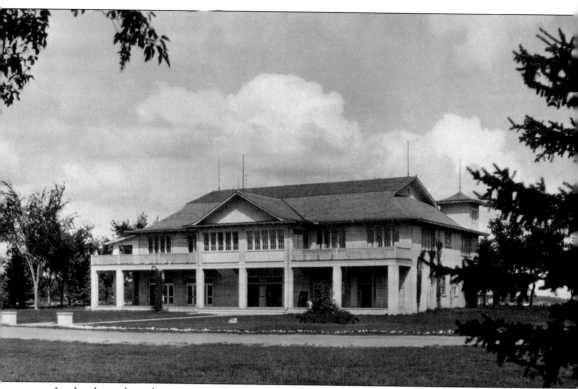

In the days when dancing was all the rage, Terrace Park's Casino Ballroom claimed to be one of the most popular nightspots in northwest Iowa. Dr. H.O. Green of Spencer, the developer of Terrace Park, opened the ballroom at the end of June 1923—in the same week as Arnolds Park's more accessible Roof Garden. The casino had nightly dancing and spectacular beachside views, but it offered more than the Arnolds Park competitor. The casino's inaugural advertising promised "the most modern and complete accommodations for Bathers in the Middle West, affording them access to the 'Most Perfect Fresh Water Beach in America'" with its bathhouse. Terrace Park was extensively damaged in a 1936 tornado, and the Casino Ballroom closed two years later. Ownership passed to the missionary order of La Salette and eventually to Boys Town for its summer camp. The building was demolished in 1962.

When a spot had the reputation for being the highest point in Iowa—even if it is not correct—it is a reputation worth preserving. The Hi-Point Supper Club and Sky Lounge perpetuated the myth, and it did offer spectacular views of West Okoboji. This is the final rendition of establishments on the hillock. Its precursor was the Hi-Point Hacienda, which was a converted Spanish-style vacation home originally built by J.A. Beck (of the Inn). The restaurant was opened in July 1941 by Dick West. In 1947, Bill and Lou Houser purchased the business, selling it in 1965 to Bud and Bonnie Osborne. It became Mr. B's Steak House about 1978 and burned to the ground in 1980. Today, this is the site of the Wahpeton water tower and a privately owned storage shed.

For many, a meal at Red's was an annual pilgrimage. Ralph Clinton knew how to cook, and his specialty as a restaurateur was hamburgers. Combine that with his crimson hair, and his nickname occurred naturally: "Hamburger Red." Clinton, born in Oklahoma in 1901, opened Red's hamburger stand in Arnolds Park in 1922. The hamburger stand grew and moved to Broadway about 1932. In 1934, Clinton opened a dinner club at Broadway and Highway 71, remodeling it in this Art Deco style. He also had restaurants in Spirit Lake and Hartley. Below, Red's Arnolds Park café interior was comfortable and up-to-date, even after a 1937 fire. To a certain few, it was known that there were slot machines on the second floor. Red Clinton died in 1979.

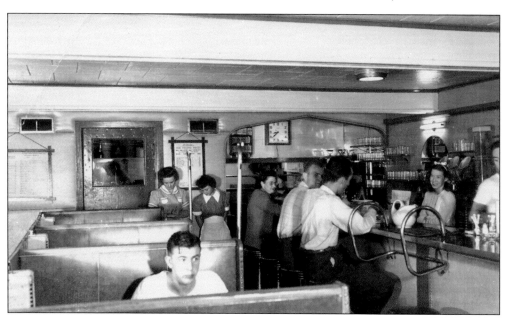

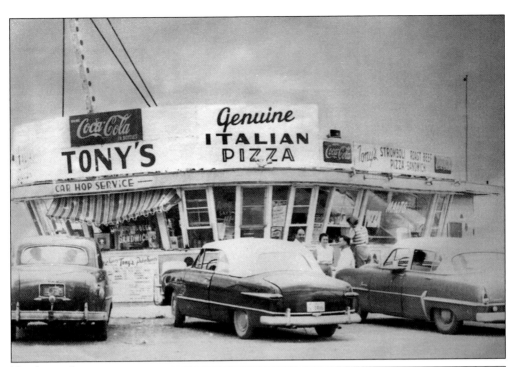

Northwest Iowa was not graced with many ethnic foods, especially Italian. But for locals and tourists alike, Tony's Drive-In was hard to pass up. Located just north of Milford at the intersection of Highways 86 and 71 in front of the Lakeland Drive-In Theater, Tony and Almeda Compiano of Des Moines opened the eight-sided fast-food shop in 1955. His pizzas and stromboli sandwiches were an instant hit. Facing more competition every year, he sold the restaurant in 1966 to Lakeland Theater owner Jim Travis following an illness.

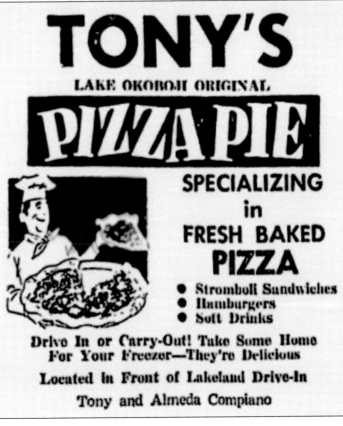

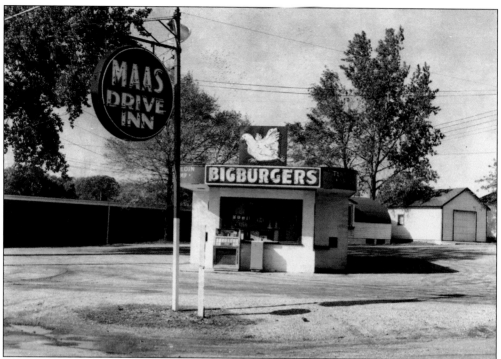

Bill Magness operated Bill's Fairground Diner at Spencer's Clay County Fairgrounds, but drive-ins were all the rage. About 1947, he put one in at Okoboji, at the intersection of Highway 71 and Sanborn Avenue (the present site of the Kum & Go convenience store). In 1950, Bill's Chicken On The Run successfully sponsored the winner of the Miss Okoboji contest. After being ordered by his doctor to exit the restaurant business, Magness put all his restaurants up for sale. Arnolds Park School superintendent E.L. Maas bought the drive-in in 1957. At some point, Treloar's, a well-known restaurant from Fort Dodge, tried its hand at Okoboji's seasonal business, with this eye-catching paint job and clever carhop attire.

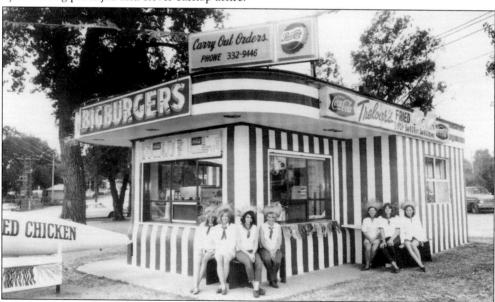

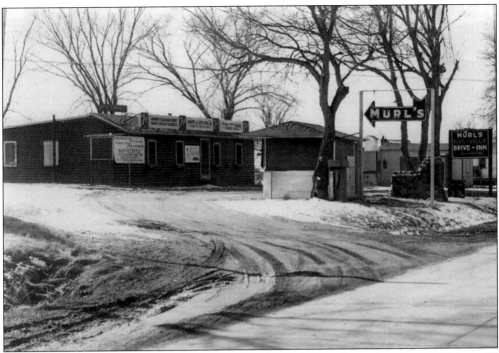

"Eat your fill for a dollar bill" was the slogan at Murl's Log Villa— located on the old Highway 71 in Maywood—and people did for years (even though the price did eventually go up). Harry and Murl Mitchell of Milford opened the doors to the Log Villa in 1953. They also owned Murl's Café at the T intersection west of Spirit Lake but sold that to focus on the Log Villa's seasonal business. News reports of the Log Villa's opening announced, "Chuck wagon chow will be featured every night with a fish fry each Friday evening." The advertisement from 1953 promises the largest sandwiches in Iowa. The business was sold to Orville Rickman in 1972.

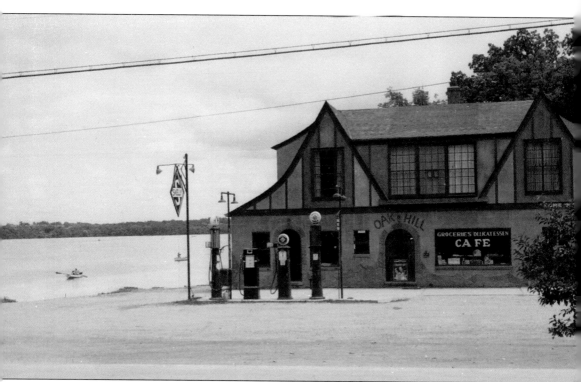

The name for the area along Minnewashta known as Oak Hill came from a descriptive early cottage name. However, by the early 1930s, Earl and Vivian (Butler) Miguel had opened the Oak Hill Restaurant and Cottages, which evolved over the years to include a grocery store, delicatessen, and gas station. Oak Hill Restaurant continued for decades, under various lessees and management. It was torn down in 2001 and replaced by the Oak Hill Marina. The Miguel family dates back to the earliest days of Arnolds Park, with Earl and Vivian Miguel among the first school graduates in 1914. A longtime promoter of the area, Earl was the county clerk for 28 years.

For certain generations, Vern & Coila's club on Pocahontas Point holds people's hearts to this day. Vern & Coila Titterington's hardware store in Arnolds Park had failed, and the couple was living with Coila's father on the southwest side of Okoboji. They set up a small grocery for cottage visitors, and when Prohibition ended, a little bar. Pan-fried chicken was requested and served, followed by pies. In 1946, they built the large supper club seen here. After Vern died in 1948, Coila's family members ran the restaurant. Open year-round—and with few dining or drinking options on that side of the lake—both the restaurant and the barroom were successful. Coila died in 1989, and the property was sold the next year. It is now the site of two large homes and a park honoring Vern and Coila.

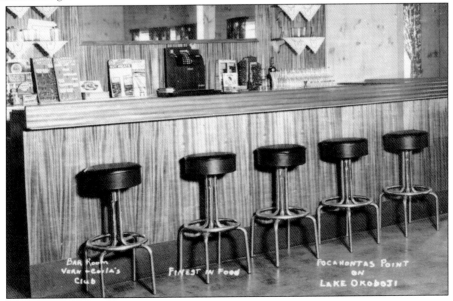

Students from Stephens College in Columbia, Missouri, have offered live stage entertainment at the Okoboji Summer Theatre since 1957. While today's performances are held in a converted 1930s airplane hangar on what was the Roy and Flossie Smith farm, this was not always the case. The area's first collegiate summer theater was called the Sanford Summer Theater, located at the south end of Maywood. It was begun in 1950 when Grinnell College's theater professor Kent Andrews leased this building, located across from the Sanford Cottages in Maywood. Plays at the tiny 100-seat theater were put on for two years at this location until Grinnell College moved the theater to the airplane hangar. Grinnell withdrew its support in 1956. In 1957, Stephens College agreed to expand its program here and took over the next year, producing summer stock with both collegiate and professional actors. Now with over 400 seats, the Okoboji Summer Theatre has been in continuous production every season since.

Eight

BUSINESS INFLUENCES

The array of businesses present today demonstrates the fragility of the tourist trade in a rural location. Rather, it is the staying power of smaller businesses that have given the area its character. Early business ventures were focused on real estate development, and the developers' names persist: Francis Sites, Van Steenburg Estates, Triboji, and Maywood. Okoboji was once highly regarded for its ice, used in iceboxes throughout the Midwest, and also renown for commercial fishing opportunities. Some businesses, like Stoller Fisheries, still exist. But few in the Iowa Great Lakes are as successful or renown as a fishing hobby pursued in the 1930s by Berkley Bedell that became Berkley & Company, now called Pure Fishing.

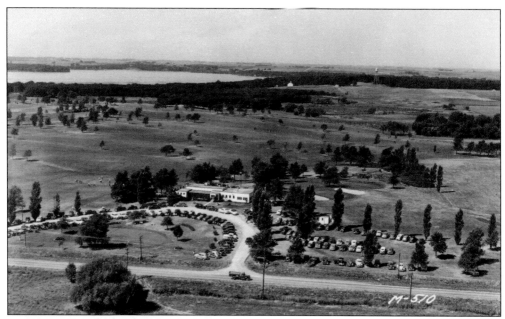

With 150 acres of farmland purchased in 1927, Brooks National Golf Course began as the Elm-Brooks golf club in 1929, just before the Depression struck. Its first clubhouse was a log cabin. Melford Brooks and his son Val Brooks struggled for years but built a new clubhouse and circular drive off Highway 71, above, in 1936. In later years, a lighted driving range was situated here. At left, founder Melford Brooks (left) enjoys a quiet moment at a golf outing with longtime friend Frank Harker, who was a Dickinson County pioneer, coming to the area in the 1880s when he helped build the Milwaukee railroad. Harker died in 1952; Brooks, in 1954.

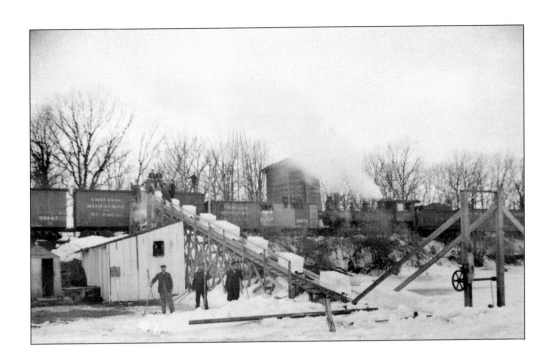

In the days before refrigeration, ice was harvested from the Iowa Great Lakes, and ice from West Okoboji was deemed among the clearest and purest anywhere. Hundreds of tons of blocks were cut from the lakes every winter and loaded into insulated icehouses for storage or shipped away on railcars. With automated loading conveyors, seen above, up to 100 railcars of 24-inch-square blocks could be loaded daily. Local customers would place cards in a front window so the iceman would know how much to bring from his truck. Coupon books, like the one seen below, were something of a novelty, but they encouraged homes to purchase and pay for ice in advance. The last ice harvests were in the 1950s.

500 LBS. 0.0 . ICE Nº 227

COUPON BOOK - NOT TRANSFERABLE

THE COUPONS IN THIS BOOK ARE NOT TRANSFERABLE AND ARE PAYABLE IN ICE ONLY

SPENCER OFFICE
240 West 6th St.
Phone 303

Park Ice CO.

HOME OFFICE
Arnolds Park
Phone 14

WHOLESALERS AND RETAILERS OF OKOBOJI LAKE ICE

SPENCER ARNOLDS PARK OKOBOJI

This was once the site of a private fish hatchery that raised carp. Between 1878 and 1880, the State of Iowa appropriated funds to purchase and enlarge the hatchery on the isthmus between Spirit Lake and East Okoboji. It was an ideal location for harvesting fish, and being on a rail line meant fish, roe, or fry could be transported by train to other parts of the state. The hatchery buildings seen here were completed in 1916 and used almost exclusively to raise northern pike, then muskies and walleye, which do not spawn well in Okoboji's waters. The current buildings were erected in 1963.

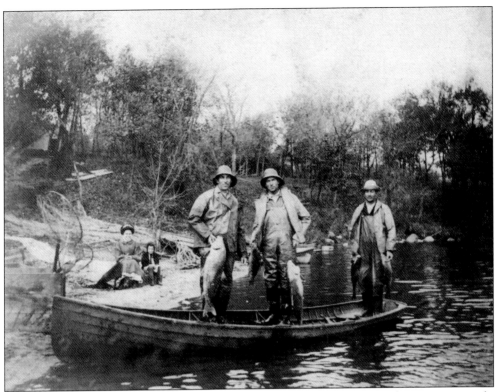

Fish like buffalo and carp were long considered desirable to have, as they were large, easy to catch, and plentiful. The fishermen in the boat seen above are obviously quite proud of their catch, which could be filleted, smoked, and provide several meals. For decades, commercial fishing crews braved inclement weather in spring and fall seining for fish. Operators like Harry Tennant would contract with fishmongers to provide rough fish for local and national markets. Founded in 1932 by Harry F. Stoller, Stoller's Fisheries in Spirit Lake was one such vendor. Seining was a difficult job, requiring crews to drag heavy nets into the lake and use hand-drawn winches and huge reels to drag the catch to shore. Seining for commercial purposes began to fall out of favor by World War II.

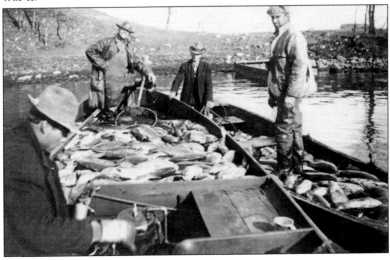

In 1930, C.F. Gipner bought a water-level building owned by cottage resort owner Kate Smith and remodeled it as a fresh fish market. With an ideal location next to the grade in Okoboji, Gipner's Fish Market was destined to have a long life. Gipner raised and enlarged it, adding a top story. In 1932, the first restaurant business opened there when Phil Coventry started the Edge Water Dining Porch, which he managed until 1948. After that, a succession of restaurant owners—including the O'Farrell sisters— managed and remodeled the building. "Fisherman's Wharf" was the enterprise's last name, which was appropriate—the landing is a worthwhile fishing spot. The building was demolished in 1999 when Highway 71 was widened.

There has been no building more recognized in the Iowa Great Lakes than the Okoboji Store. It was built by S.E. Mills as a roller-skating rink with boat livery beneath. The rink never materialized, and Mills converted it to the town's post office and store in the front room. In 1888, W.S. Wilson took over as postmaster and storekeeper, and it stayed in the Wilsons' hands for decades before being sold to Tom Olson in 1922 and S.A. Nelson in 1943. Eventually, the Wilson boat livery business grew and spread to the point. In the below photograph, Wilson & Sons, Boatmen is the business name, which later became Wilson Boat Works. It is now Mau Marine and—in a surprising twist—the Okoboji Store, a restaurant. Note the steamboats moored alongside the grade. This was the coal dock.

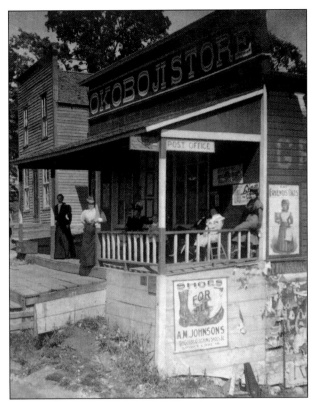

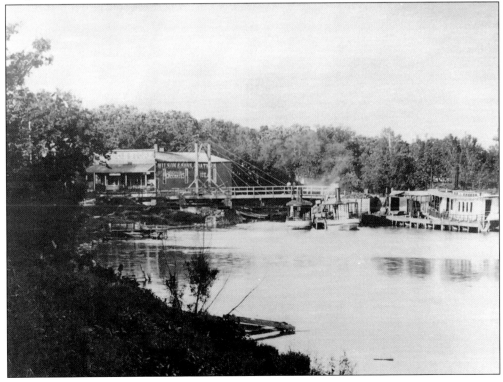

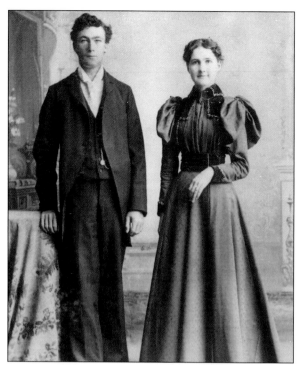

Ed Wilson, son of Okoboji postmaster W.S. Wilson, married Lou Roff in 1897; this is likely their wedding photograph. Lou was the daughter of Fred Roff, builder of the *Okoboji* steamer and others. Ed was the Okoboji store owner. Two of this couple's well-known children were Harry "Zeke" Wilson (died 1994) and Fred Wilson (died 1995). Wilson Boat Works grew in prominence during their ownership.

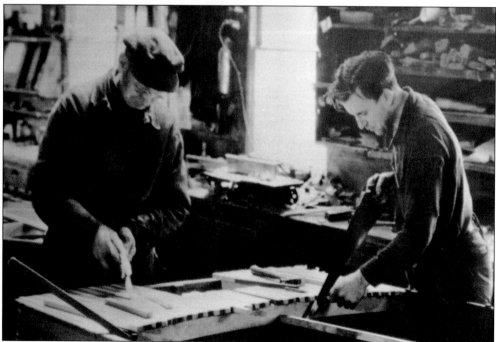

A true pioneer of the boating industry, John Hafer built rowboats, sailboats, and runabouts from his shop on East Okoboji in the town of Spirit Lake. The painstaking dedication of John and his son Glenn (right) meant Hafer Craft were both finely crafted and durable. John died in 1957, and Glenn carried on the boat works until 1968, making it among the longest-lived businesses in the area. Glenn died in 1994.

Although he moved to Des Moines in 1917, attorney and state senator L.E. Francis purchased 800 acres of what was then known as Tusculum Beach. In 1919, trees were cleared, roads put in, and before long, 500 lots were platted for sale with tidy cottages erected. Even today, many of the Francis Sites houses represent the growth seen in the Iowa Great Lakes in the 1920s.

The promise of future development at new Echo Bay Park is evident in this 1922 photograph. Developers invested in pathways, benches, and rustic bridges to lure visitors. Located near the Inn, 90 lots were planned but by the time the Depression hit, only a few had been purchased. While this pillar no longer stands, its matching companion can still be seen on Lakeshore Drive. (Courtesy of Dickinson County Historical Society.)

DISCOVER THOUSANDS OF LOCAL HISTORY BOOKS FEATURING MILLIONS OF VINTAGE IMAGES

Arcadia Publishing, the leading local history publisher in the United States, is committed to making history accessible and meaningful through publishing books that celebrate and preserve the heritage of America's people and places.

Find more books like this at
www.arcadiapublishing.com

Search for your hometown history, your old stomping grounds, and even your favorite sports team.

Consistent with our mission to preserve history on a local level, this book was printed in South Carolina on American-made paper and manufactured entirely in the United States. Products carrying the accredited Forest Stewardship Council (FSC) label are printed on 100 percent FSC-certified paper.

MADE IN THE USA